Celebrate your Creative Self

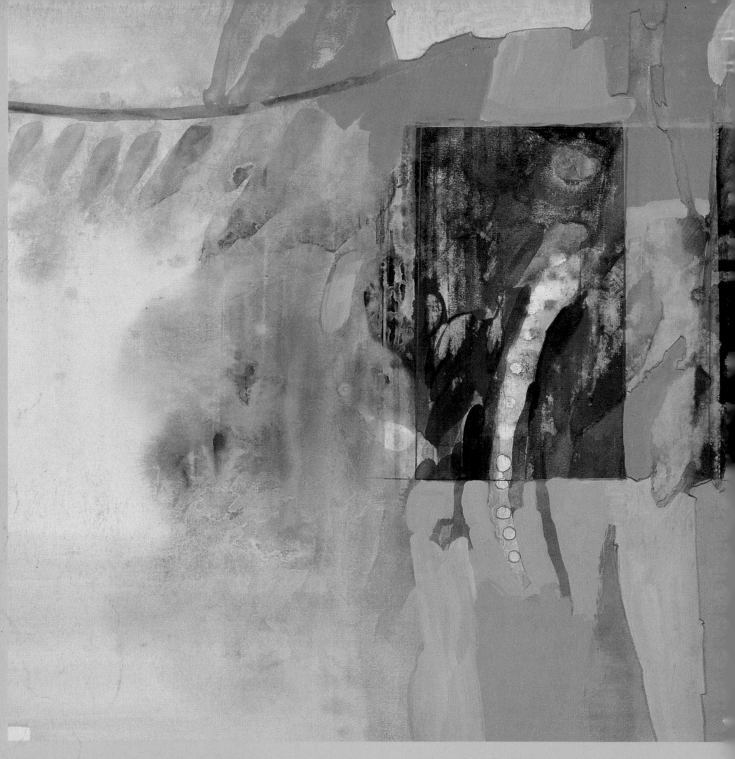

PASSAGE OF TIME * Mary Todd Beam * 20"×40" (51cm×102cm) * Acrylic and watercolor on illustration board * Collection of the artist

"Trust yourself, we are all born to be great at small things, it just takes a little courage and creative thinking." —Sally Emslie

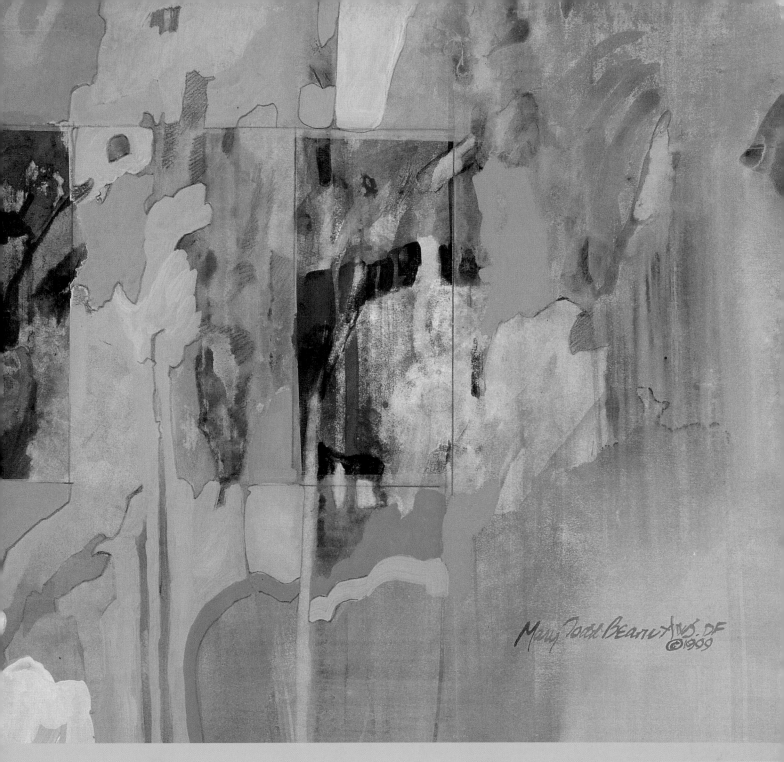

Celebrate your Creative Self

MORE THAN 25 EXERCISES TO UNLEASH THE ARTIST WITHIN

by Mary Todd Beam

NORTH LIGHT BOOKS
CINCINNATI, OHIO

www.artistsnetwork.com

ABOUT THE AUTHOR

Mary Todd Beam, painter, popular workshop instructor, juror and lecturer, is an elected member of the American Watercolor Society (where she became a Dolphin Fellow and won their Gold Medal of Honor in 1996), the National Watercolor Society, the Society of Layerists in Multi-Media, the Ohio Watercolor Society and many others. She has been the juror for state, local and national exhibits such as the National Watercolor Society's Annual Exhibit and the Rocky Mountain Annual Exhibit. Her work has been chosen for inclusion in several major exhibits, including the National Academy of Design's Biennial in New York. She has won awards from many major exhibits, including the Ohio Watercolor Society's Silver and Bronze medals, the Top Juror's Award in the San Diego Watercolor Society's Annual Exhibit and the Experimental Award in the National Watercolor Society's Annual Exhibit, to name a few.

Her work was recently featured in *Watercolor Magic* magazine, and her artwork and text have been featured in several books on painting, most notably Maxine Masterfield's *Painting the Spirit of Nature*, Nita Leland's *The Creative Artist* and Michael Ward's *The New Spirit of Painting*. She is listed in *Who's Who in American Art* and the *World's Who's Who of Women*. Her work appears in collections both in the United States and abroad.

Mary maintains two studios: one in Ohio and one in the Smoky Mountains in Tennessee, where she spends most of her time exploring nature as the basis of her interpretive painting and cherishing the hours she shares with the mountains, streams and forest. Her husband, Don, since retiring, accompanies Mary on many of the workshops she is involved in. He expresses his artistic talent by working with found objects. Mary is represented by the Art Exchange in Columbus, Ohio.

Other fine North Light Books are available from your local bookstore, art supply store or direct from the publisher.

05 04 03 02 01 5 4 3 2 1

Library of Congress Cataloging-in-Publication Data
Beam, Mary Todd
Celebrate your creative self: more than 25 exercises to unleash the artist within/by Mary Todd Beam.
 p. cm.
Includes index.
ISBN 1-58180-102-5 (alk. paper)
1. Painting—Technique. I. Title.

ND1471 .B43 2001
751.4—dc21 2001030986

Edited by Jennifer Lepore Kardux
Cover and interior designed by Wendy Dunning
Page layout by Kathy Bergstrom
Photography by Al Parrish
Production by Emily Gross

The permissions on pages 140–141 constitute an extension of this copyright page.
Artwork on cover: *Sedona Memories* (detail), Mary Todd Beam, 24" × 48" (61cm × 122cm), Acrylic on canvas, collection of the artist (full painting on pages 38–39)

METRIC CONVERSION CHART

to convert	to	multiply by
Inches	Centimeters	2.54
Centimeters	Inches	0.4
Feet	Centimeters	30.5
Centimeters	Feet	0.03
Yards	Meters	0.9
Meters	Yards	1.1
Sq. Inches	Sq. Centimeters	6.45
Sq. Centimeters	Sq. Inches	0.16
Sq. Feet	Sq. Meters	0.09
Sq. Meters	Sq. Feet	10.8
Sq. Yards	Sq. Meters	0.8
Sq. Meters	Sq. Yards	1.2
Pounds	Kilograms	0.45
Kilograms	Pounds	2.2
Ounces	Grams	28.4
Grams	Ounces	0.04

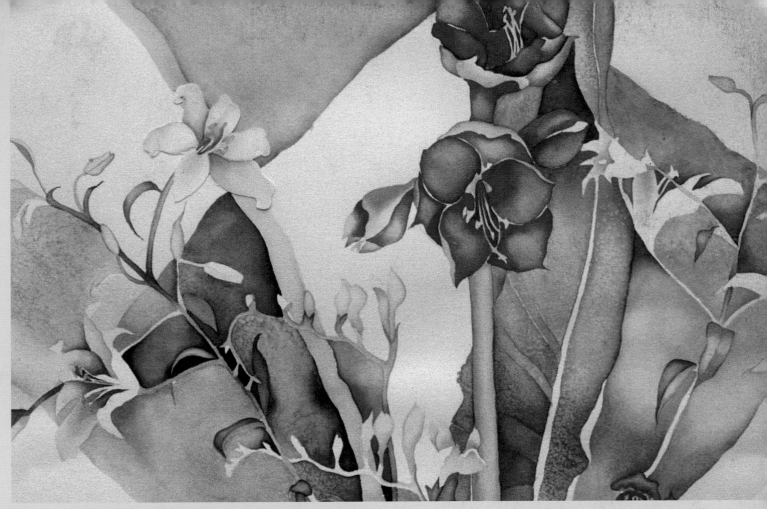

FLORAL II * *Julie Beam* * *22" × 24" (56cm × 61cm)* * *Watercolor on paper* * *Private collection*

DEDICATION

This book is affectionately dedicated to the

memory of our daughter, Julie, a talented artist,

loving daughter, sister and granddaughter,

who has found her ultimate creative self.

ACKNOWLEDGMENTS

My heartfelt thanks goes to F&W Publications, Inc., for publishing this book; to Rachel Rubin Wolf, who requested this book; to my editor, Jennifer Lepore Kardux, who tenderly guided and nudged me through these pages; to designer Wendy Dunning; to photographer Al Parrish; and to Amber Traven for her ideas and guidance at the photoshoot. And thanks to those who participated in the photoshoot as workshop students: Jennifer Long, Libby Fellerhoff and Amber Traven.

Thanks to Golden Artist Colors, Inc.®; Crescent Cardboard Company, L.C.C.; and Da Vinci Paint Co. for contributing some of the supplies used to make the artwork in this book.

Thanks to Winnifred and Don Dodrill for their encouragement; to Vera Jones who was at my side with the captions, slugs and other numerous details; and to my husband, Don, who kept me at the computer, guarded my quiet working time, brought me all sorts of refreshments and prodded me along when I wanted to go play. Finally, I want to thank God for giving all of us the gift of creativity and the love of painting.

Table of Contents

"There is a sacred essence in each human. This can only be realized and shared when we go beyond ourselves and reach beyond our limits." —Mary Todd Beam

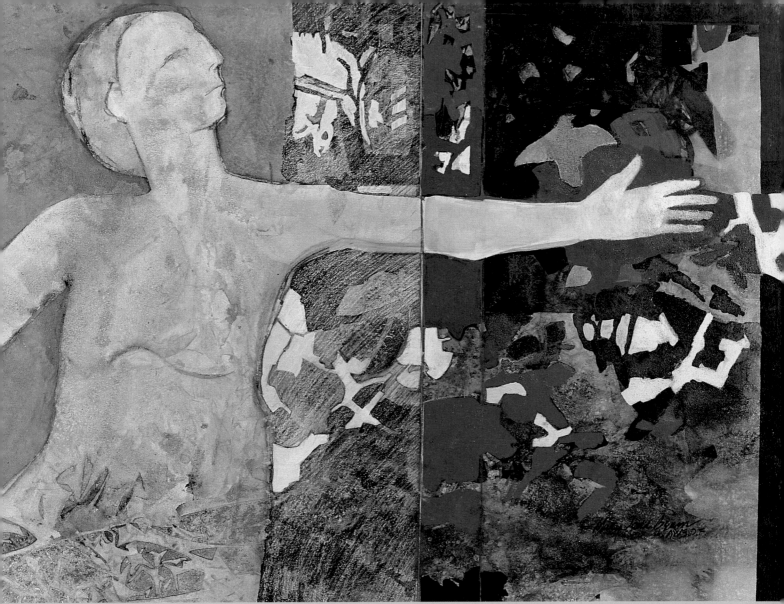

DAWN OF CREATION ✳ *Mary Todd Beam* ✳ *30"×40" (76cm×102cm)* ✳ *Fluid acrylics and gesso on illustration board* ✳ *Collection of Dr. James Mitchell*

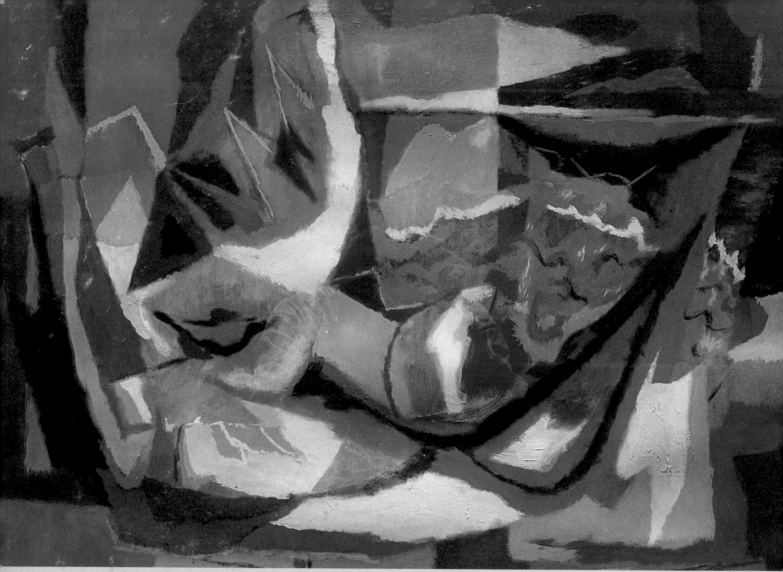

RED SPOT * *Dr. Charles Dietz* * *18"×21" (46cm×53cm)* * *Acrylic* * *Collection of the artist*

Foreword

As director of the Zanesville Art Center for forty-two years, I had an intimate look, critically, at many of the finest practicing artists of the area. Mary Todd Beam, who exhibited in a one-man show and many group shows at the center, is one of the most important of the painters. Her strongly incisive and original work-style merits close attention. It expresses a very emotionally sensi-tive nature interpreted in painterly terms—color, line and shape—and in an effective and affective manner or style—essentially abstract in character and emotionally strong in total feeling.

Dr. Charles Dietz * *Director Emeritus*
Zanesville Art Center * *Zanesville, Ohio*

Charles Dietz

Introduction

Create

*To bring into being; to cause to exist.
To invest with a new form, office
or character; to constitute.
To produce as a work of thought or
imagination, espy. as a work of art.*
—Merriam Webster's Collegiate Dictionary

Creative

*Having the power or quality of creating.
The act of causing to exist.*
—Merriam Webster's Collegiate Dictionary

OUR LEGACY

How exciting! Cezanne said that the artist paints the next moment in time. Could we ever imagine anything more exciting than becoming a partner in creation? What a thrill it is when we show the world the form and substance of an idea that has never before been seen. Only the artist can do this. The artist is developing a code that brings a whole new understanding and enlightenment to his thoughts, his emotions and his place in the universe.

So you want to be creative? Well that's the first step. Now I must warn you, it won't be easy, but it will be challenging and rewarding—and never boring.

UPGRADING PAINTING SKILLS

Somewhere along the way in our artistic search someone stresses drawing skills. They say, "We must learn our drawing skills." Rightly so. And there are many who think that the act of painting is merely drawing with paint. They keep that idea through their whole artistic career, making art that is drawn and filled in finally with paint. But seldom does anyone mention painting skills.

WHY READ THIS BOOK?

This book is an attempt to expose the artist to painting skills. I am not trying to clone myself and have offspring who paint like me. I want to give artists a set of painting skills that they can store in their mind and draw upon as needed when they want to express their unique statements, whether they come from working with a new surface or painting with opaque watercolor.

We are painters first, artists always, and as such not bound by anything but our innate desire to create.

MOVE ON. CLEAR YOUR PATH.

We have all gathered some habits along the way as we learned to paint. Some of these habits may get in the way of or hinder the creative process.

To invest in a new form we need to get rid of the old one. We need to try to reach into the unknown and drag it into our space so that it will be useful to us. At first, this unknown place is uncomfortable. We tend not to like this kind of surprise or risk and we fear failure.

With the projects in this book, I will try to guide you in a direction that may open windows to the unknown, to your creative self.

The more we practice reaching into and prodding the unknown, the more we see that it is the only place to be and the most rewarding for us as creators. We even may grow to like it. I certainly do!

GET CREATIVE!

•

Be willing to shed some old habits. Erase what has gone on before. Take risks. Let go! Clear the deck! Jump right into the water!

•

Agree to suspend judgment.

•

Squelch the desire to do the predictable. Find new solutions to the dilemmas facing you.

•

Be brave enough to bring your life and life experiences into your work. There is something only YOU can give to art.

•

Be bold and daring enough to make a meaningful statement.

Materials

Have you ever heard the saying, "Place an artist in the desert and she will find something there to make art"? I was placed by fate in a kitchen for many years and I found that it was a place rich with materials to be explored. Whenever I was faced with a problem in my work, I'd wonder what was at hand I could use to solve that problem. At least it made doing the daily chores more palatable.

I don't place a great deal of importance on materials. I think you will find whatever you need to do the job wherever you are. I've heard of artists using dryer lint to make art. At least these supplies are inexpensive and maybe this comes from a desire not to be wasteful. The artist's mind is still the most important ingredient in making art.

Hardware Store Supplies
These include adhesive spreaders, glue, clips and clamps, utility knives, foam brushes, sand, hog bristle brushes and dropcloths.

SURFACE

Any surface of your choice can work for you. I prefer Crescent illustration board due to its thickness and durability during my experimental techniques.

BRUSHES

The only three brushes I would be hard pressed to do without are a 1-inch (25mm) acrylic flat, a ½-inch (12mm) acrylic flat and a 3-inch (75mm) cheap bristle brush found in most hardware stores. For my style, round brushes don't make the right marks or edges. A flat gives a good, sharp edge and you can turn it around and use all its sides for different marks. Of course, an adhesive spreader is handy, too. Experiment with different brush sizes to see which feels most comfortable for you and your style.

PAINT

I keep two palettes set up in my studio. One is a limited palette made up of fluid acrylics and one is a limited watercolor palette. I can add other colors as I wish, but this seems to suit my needs.

My acrylic palette consists of Golden Fluid Acrylics—Quinacridone Gold, Turquoise (Phthalo) and Quinacridone Crimson. I enjoy mixing colors, so the three fluid acrylics I have selected are very strong stainers. You can use fluids in a transparent technique: Their bond is strong and flexible and accommodates the use of much water in the washes.

My watercolor palette usually consists of Phthalo Blue, Yellow Ochre, Burnt Sienna, Raw Sienna and Alizarin Crimson. These colors work well with my acrylic color selection.

I feel no obligation to stick to these palettes and I could change my mind any day, but for now this works for me. It also keeps my decisions and choices to a minimum, which helps when traveling.

I hope no one will feel constrained to think these are the only colors that can be used. Create your own palette according to your likes and personality.

Kitchen Supplies
These include paper towels, Styrofoam cups, plates, plastic sacks, aluminum foil, scissors, canning wax, salt, adhesive shelf liner (Con-Tact paper), sponges, window cleaner, freezer wrap, dishwasher rinse aid and plastic spoons.

Art Store Supplies
These include fluid acrylics, watercolors, gel mediums, gesso, flow enhancer, crayons, brayer, markers, brushes, stamps and paper.

ACRYLIC-BASED PRODUCTS

There are so many interesting products on the market today. The base used to produce acrylic paint lends itself to much versatility.

Companies are adding mica, crushed in different strengths and ways, to make *iridescent* and *interference* paints. *Mica flakes*, *ground sands* and *pumices* are added to acrylic bases for increased textures. *Metallic* paints are popular now as well.

Gel mediums are used to create glazes, extend paints, build textures or change finishes, or can work as a gluing agent. I prefer the consistency and variety of Golden gel mediums.

Gesso was formulated to use as a base coat on any painting surface where acrylics are to be used. It allows the painter to become more creative by giving him a new surface of his own design to explore.

FLOW ENHANCER

This product breaks the bond of the paint to make the paint flow more readily. I use Golden Acrylic Flow Release, which is specifically made for this function. However, one of my students found that Cascade Rinse-Aid reacts with paint in a similar way.

You can use your flow enhancer as a resist to get whites back, or as a tool to create symbols or organic shapes in your wet paint.

SAFETY ISSUES

1. Look for the Safety Testing logo on products.
2. Make sure your work area is well-ventilated.
3. Don't ingest your painting products.
4. Don't eat while working.
5. Use a mask if your painting product is in powder or spray form.
6. Be aware that many products are not for use by children.

KEEP YOUR BRUSHES CLEAN

Soaking your acrylic brushes in Murphy's Oil Soap will clean and soften dirty brushes.

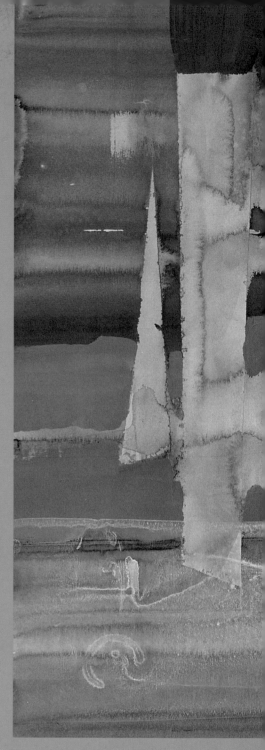

"The perception of light in a painting is the loveliest thing in the world."

—As remembered by the author from an Edgar Whitney lecture.

1 Encountering the White

Whether it's a flicker of light on a face, a shimmering reflection upon water or a ray of sun cascading through a window, these delights relate to all human spectators. Wherever it is a literal manifestation in the work or an abstracted element, light compels the viewer.

This chapter reviews various ways to achieve light in your artwork. You will train your eye to spot or focus on white or lights in your surroundings. Your attention will focus upon the importance of shapes by drawing and cutting them. You will paint using whole-body movements that increase the flow of energy to the paper. You will learn the importance of layering and underpainting.

GATHERING SKILLS

You are learning to build up in your mind a repertoire of techniques. When you're developing or becoming inspired by a subject or idea, you can go to this menu of techniques and select the one that best accommodates your inspiration.

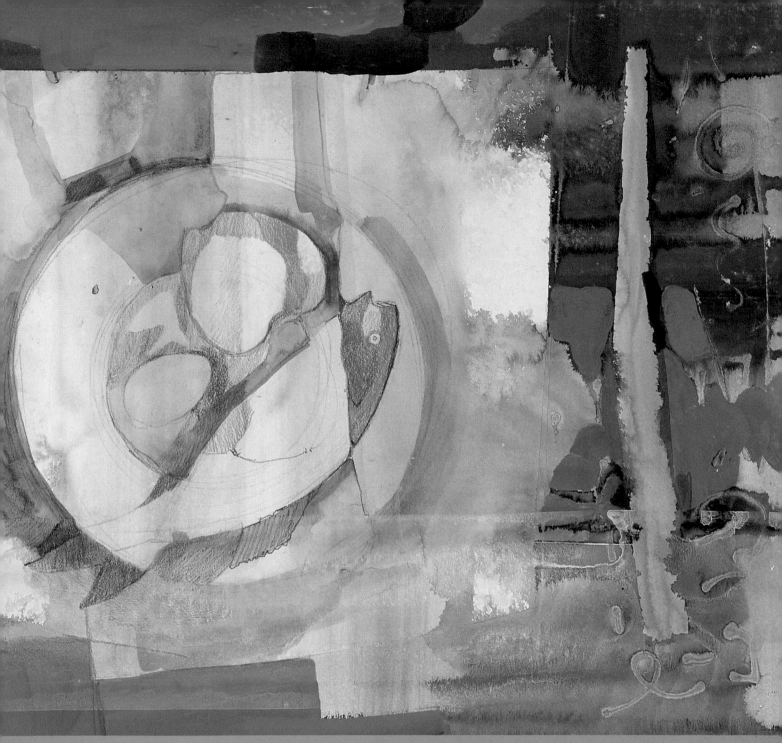

COMING TOGETHER ∗ *Mary Todd Beam* ∗ *22" × 30" (56cm × 76cm)* ∗ *Acrylic on illustration board* ∗ *Collection of the artist*

painting around
THE WHITE

With this technique you isolate the white shapes and hold them as positive shapes, painting the negative background shapes. It may take some practice to develop an eye for negative shapes, but keep at it. Painting around an object will help you to look at your subjects in a new way—as shapes and spaces—and can help you create your art in a new way too.

1: BEGIN PAINTING
After sketching your painting idea, begin painting around areas to leave white, isolating the whites and changing values with your paint. I use varied mixtures of Alizarin Crimson and Phthalo Blue around a flower subject.

2: ADD DARKS
Painting in Burnt Sienna and Yellow Ochre will add contrast, and when mixed with other colors will help vary the values and pop out whites. Continually paint and reshape by painting around what's already there.

3: SOFTEN EDGES
Use clean water to brush along edges of white to tone and soften edges.

WHITES ARE BRILLIANT

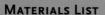

MATERIALS LIST

Surface
Any watercolor paper or illustration board

Brush
1-inch (25mm) flat acrylic

Paints
Watercolors: Alizarin Crimson, Burnt Sienna, Yellow Ochre, Phthalo Blue

Other
Soft drawing pencil

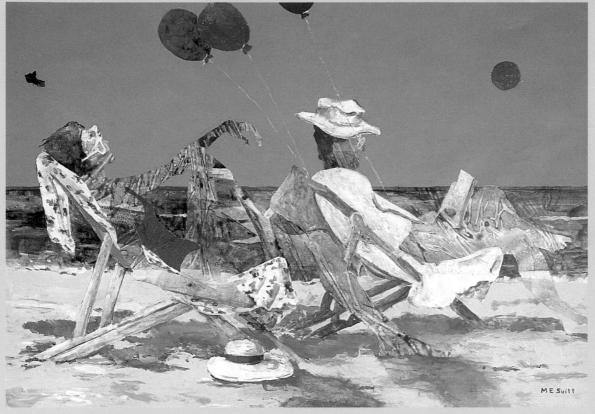

Knowing where and when to use opaques takes a touch of genius, and Mary Ellen Suitt knows that at times opaques surrounding your subject matter will make them seem more special. The flat, deep sky makes the textured color and whites stand out. The opaques help focus attention on the subject of the painting.

TIME OUT * *Mary Ellen Suitt* * *22"×30" (56cm×76cm)* * *Acrylic on paper* * *Collection of the artist*

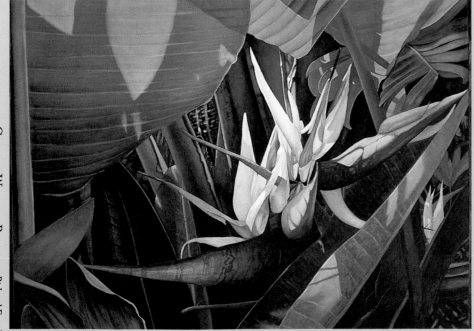

Great White Bird * *Richard French*

* *28"×40" (71cm×102cm)* * *Transparent watercolor on paper* * *Collection of Suntrust Banks*

French has a way of spotting the white that matters. He frames the white with darks, but doesn't forget to make it the most important feature in the painting. Developing the ability to spot whites or lights in a creative manner adds much drama to a painting.

SEARCH OUT WHITE SUBJECTS

Take your notebook and search for subjects that feature whites or lights. Spotting these subjects can be a challenging game and a means of training the artistic eye. When you find such a subject, consider it a sacred object not to be sullied by paint. Try sketching it to remember the patterns of positive and negative shapes.

capturing
THE BIG LIGHT

W hen you have a subject that contains large white areas, try saving them with adhesive shelf liner. I've never enjoyed using a mask that has to be dabbed on. The adhesive shelf liner will give you clear, sharp edges.

With adhesive shelf liner, you can create a "window," focusing the viewer on a subject or an event in your painting. You can hold true whites and use them adjacent to darks to create a feeling of depth.

The results with adhesive shelf liner are not always predictable, but using it allows you to become creatively active in discovering personal shapes of your own design.

MATERIALS LIST

Surface
Illustration board

Brush
3-inch (75mm) flat bristle brush

Paints
Fluid acrylics: Turquoise (Phthalo),
 Quinacridone Crimson,
 Quinacridone Gold

Other
Marker
Knife or razor blade
Adhesive shelf liner (Con-Tact paper
 or a brand from your local grocery
 will work just fine.)

1: CREATE SHAPES
Stick the adhesive shelf liner paper onto your illustration board. Use a marker to draw shapes, dividing up space and thinking of design.

2: CUT OUT SHAPES
Cut away the adhesive shelf liner from the background, leaving the adhesive liner on the shapes.

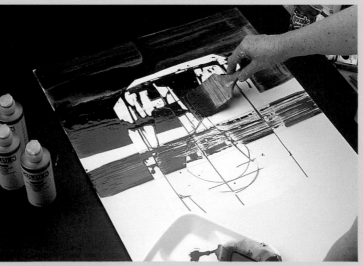

3: ADD PAINT
Float thick paint washes across the whole board, mixing colors for variety and contrast. When done, let it dry and peel off the adhesive shelf liner.

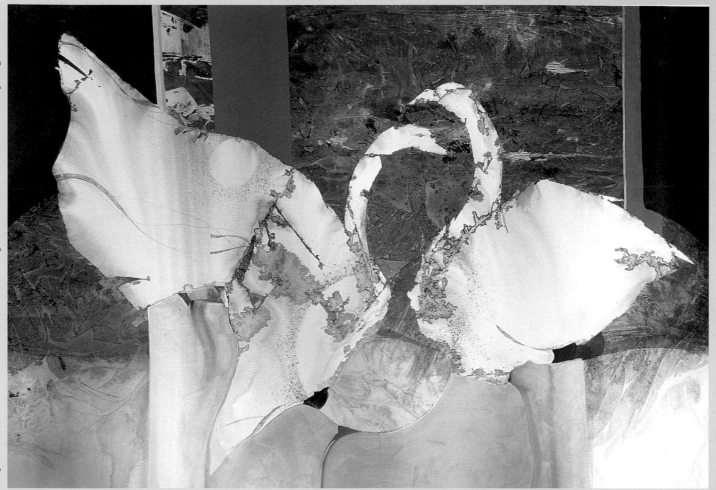

Swansong * Mary Todd Beam * 30"×40" (76cm×102cm) * Acrylic on illustration board * Collection of Margaret Anderson

The swans were covered with adhesive shelf liner and then the whole board was covered with acrylic paint. Paint was lifted from the middle area with a sponge, allowing the paint to stain and make a negative printing.

DOODLING FOR NEW SHAPES

We can tap into our creative mode by allowing things to happen by accident. Try combining three different shapes—a circle, square and triangle— to develop randomly inspired new shapes.

lifting color to
BRING BACK WHITE

Lifting is a valuable technique for the watermedia painter to learn, whether you lift just a portion of the painting or whether you use a lifting technique throughout.

Lifting results in a very gentle, soft look. I like to lift from a hard-surface paper such as illustration board. It seems to absorb just enough paint, but allows the artist to lift the paint that remains on the surface.

While this demo works with watercolors, be aware that acrylics can be lifted with the same method, leaving stained areas for a yin-yang effect.

I often use a partial lifting process to establish a design format or to bring back some lights or midtones to a painting.

MATERIALS LIST

Surface
Illustration board

Brushes
Foam brushes (several sizes)
3-inch (75mm) bristle

Paints
Watercolors: Alizarin Crimson, Burnt Sienna, Yellow Ochre, Phthalo Blue

Other
Soft drawing pencil

1: BEGIN PAINTING
After sketching your subject (this demo shows a floral theme), divide the paper into unequal divisions and lay thick flat washes of color on with your 3-inch (75mm) bristle brush. I've used Burnt Sienna and Yellow Ochre to start with a neutral base.

2: INCREASE VALUES
Charge heavier pigment onto the board. Adding Alizarin Crimson and Phthalo Blue to the neutral base deepens value and adds variety.

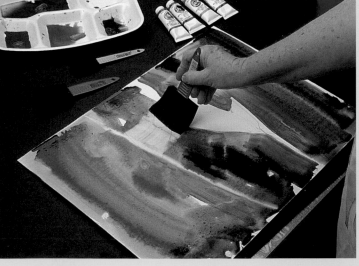

3: LIFT PATTERNS OUT OF THE PAINT
Lift patterns with a wet foam brush, thinking of your subject. Stop and start with your lifts. Drag lightly over stark white to get good tone. Try scumbling with the tip of the brush. You'll want edges to bleed to lead the eye around the painting. Leave hard edges in places where you want to move the eye quickly around the painting.

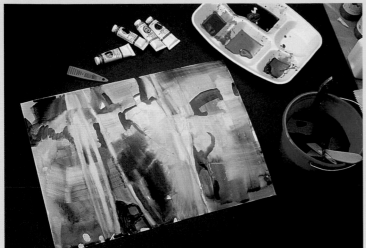

4: ADD FINAL TOUCHES

Add to the painting now to get more effects. Think about shape and about leading the eye through the painting. Use wet-in-wet or charging techniques to manipulate your paint. Thread colors through the painting for good design and color repetition. Reds, blues and dark values help your eye move through the painting.

By adjusting the pressure on the brush or lifting device, you will vary the amount of color lifted and create different values, as done in this painting.

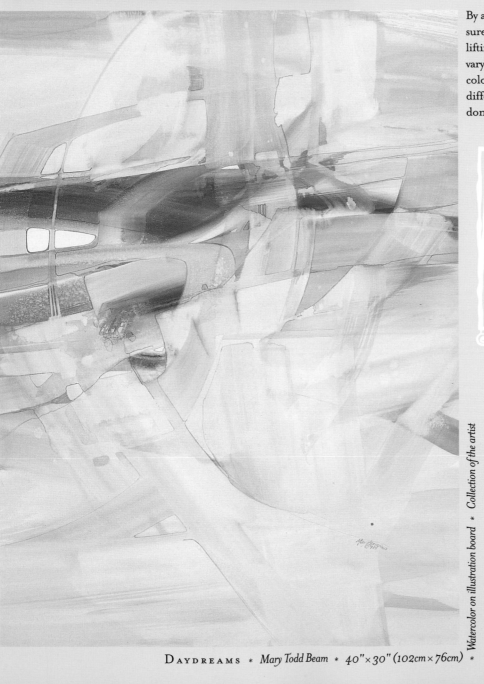

DAYDREAMS * *Mary Todd Beam* * *40"×30" (102cm×76cm)* * *Watercolor on illustration board* * *Collection of the artist*

EXPERIMENT WITH LIFTING

You can also lift with kitchen sponges, paper towels, lace or fabrics. Observe the different effects each creates and how you can use them to create various tonal values in your painting or to recapture lights when needed.

Using Resists to Capture White

Crayon and canning wax can make some interesting textures while keeping whites in the painting. It's always surprising and intriguing to see what happens when you float a fluid wash over an area where crayon or wax has been applied. This often stimulates the imagination and brings some interesting organic devices into play.

"Creativity takes over the moment I become inspired by the vision of something I want to share with the viewer of my work. Editing elements in or out, pushing or subduing or changing colors are all part of the creative process."
—Richard French

Wax resist with watercolor

Wax resist with acrylics

Pastel crayons with watercolor

Wax and pastel crayons with watercolor

Different Effects With Different Mediums
Combining crayon or wax with acrylic or watercolor can produce different results. Varying pressure when applying the crayon or wax will also alter your results. Press hard for strong resists.

OTHER PRACTICAL USES FOR WAX

Coat the edges of your illustration board with wax before painting on it. Cut a piece from a block of canning wax and run it along the edges of the board on all sides. This will keep the paint from seeping into the layers of the board and making the board pucker.

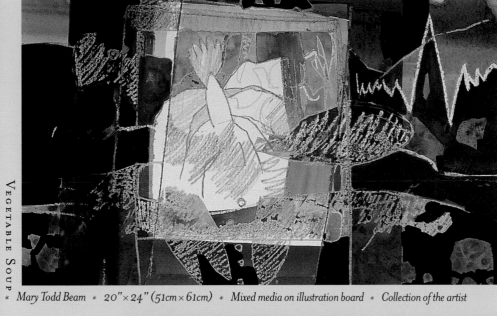

Wax, crayon and adhesive shelf liner save the whites in this painting. I was cooking soup the day I worked on this and the shapes kept reminding me of that chore, hence the title.

* *Mary Todd Beam* * *20"×24" (51cm×61cm)* * *Mixed media on illustration board* * *Collection of the artist*

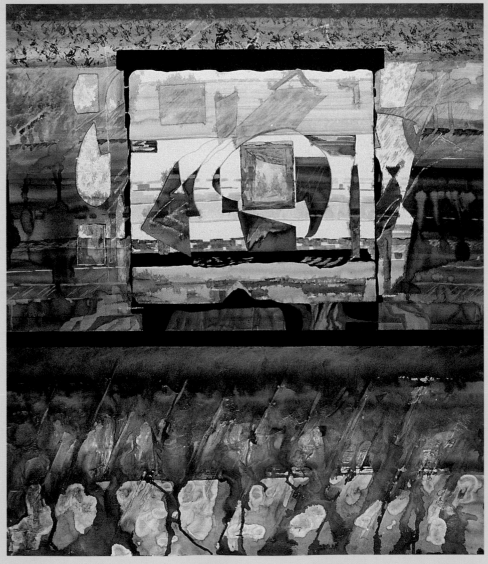

EXPLORATION * *Kay Tierney* * *40"×30" (102cm×76cm)* * *Mixed media on illustration board* * *Collection of the artist*

Tierney uses adhesive shelf liner to save larger pieces of white, which makes a stark contrast between the white and the lush painterly color. Her subtle use of crayon resists paint in some areas, giving an additional layer to her painting.

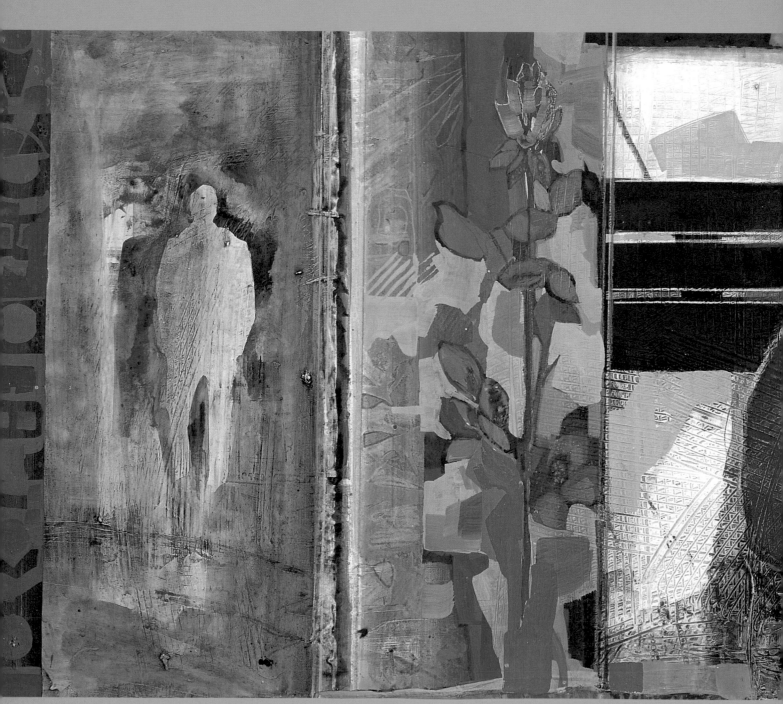

A Rose for Rhoda * *Mary Todd Beam* * *15" × 30" (38cm × 76cm)* * *Watercolor on distressed gesso and mixed media* * *Collection of the artist*

2 Creating Your Personal Surface

I was amazed when I changed to a hard surface how I could manipulate the paint for juicier washes. Then I discovered that I could achieve new results by covering the paper with gesso, even sculpting out shapes with the gesso to obtain an organic response. Now that you've decided you need to be more creative, jump-start that process without too much change or effort by changing the surface that you work on. Changing surfaces can get you started making paintings that are more personal.

PAINTING IN A PERSONAL MANNER

1. *Paint flows freely from your brush in a relaxed manner.*

2. *The subject matter comes from your everyday life experiences.*

3. *Each painting grows from your previous work.*

4. *Each painting contains a measure of personal symbols.*

5. *You are sensitive and responsive to developments in your work.*

6. *You are willing to change preconceived plans when changes are offered.*

Making a Chart of Surfaces

ARE YOU DRAWN TO TEXTURES?
Look at this chart before starting your painting and see if there is a texture you want to use. One of these textures may be more suitable than another, depending on the ideas and subject matter you want to present in your painting.

WARNING

Never use commercially colored tissue paper. It is not lightfast, and will fade or change color over time.

You can add color to tissue with paint before the tissue is applied. Just let the paint dry and then apply the tissue to the painting. Or you can add color after the tissue is applied. Just let the tissue dry into the painting first, and then apply color.

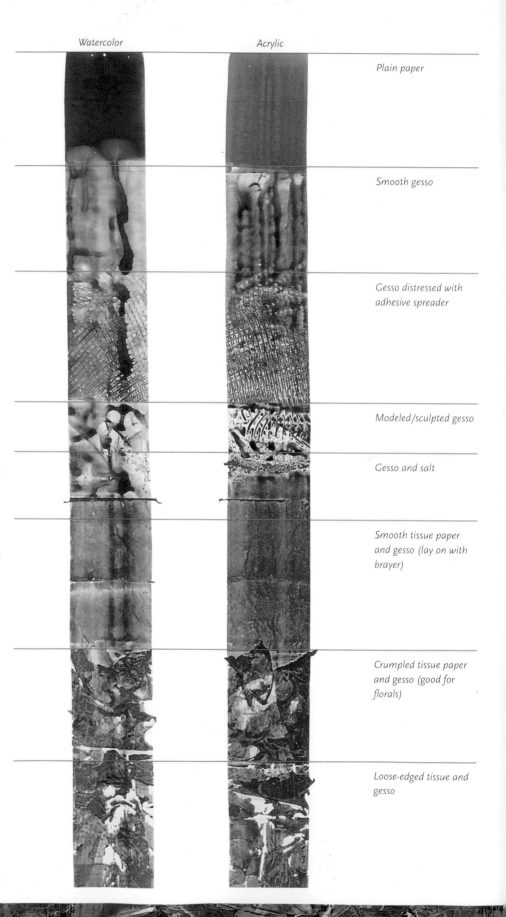

Watercolor Acrylic

Plain paper

Smooth gesso

Gesso distressed with adhesive spreader

Modeled/sculpted gesso

Gesso and salt

Smooth tissue paper and gesso (lay on with brayer)

Crumpled tissue paper and gesso (good for florals)

Loose-edged tissue and gesso

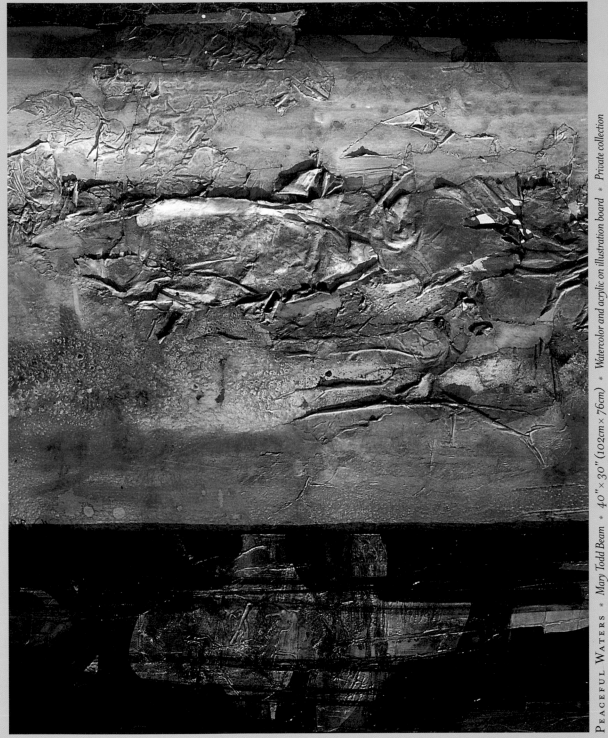

PEACEFUL WATERS * Mary Todd Beam * 40" × 30" (102cm × 76cm) * Watercolor and acrylic on illustration board * Private collection

Getting to the Heart of It

How can we be in tune with the ebb and flow of nature? Can we reduce the subject matter to one word? Can we merely express her essence? Can we make the paint mimic her actions and thereby produce a flowing, spontaneous effect in the eyes of the viewer?

Try harnessing nature's spirit by flowing paint in a fluid manner: Letting it go where it may, stopping its flow at intervals. Use organic bits and pieces to suggest accidental happenings. Frame all of this with some quiet resting places.

creating a TISSUE or RICE PAPER SURFACE

Most of us are drawn to the beauty of flowers. A sensitive floral takes advantage of the subject by reminding the viewer of the fragility of life. Nature works in a random and generous fashion, and you can produce similar effects by allowing the paint to do the work.

You can learn to crumple rice paper or tissue paper before applying it to the gesso for an organic look. When the paint is applied it will flow into crevices that appear to be veins in leaves. The paint can mimic the look of stems, leaves and petals of the flowers. The rice or tissue paper allows for a very transparent and fragile reading of the areas where it is applied.

MATERIALS LIST

Surface
Illustration board or watercolor paper

Brushes
1-inch (25mm) flat acrylic
3-inch (75mm) flat bristle

Paints
Fluid acrylics: Turquoise (Phthalo),
 Quinacridone Crimson,
 Quinacridone Gold
Watercolors: Alizarin Crimson, Burnt
 Sienna, Yellow Ochre, Phthalo Blue

Other
Gesso
Tissue or rice paper (Rice paper is
 more archival.)
Adhesive spreader
Flow enhancer
Graphite and colored pencils

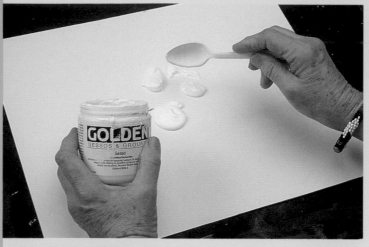

1: APPLY GESSO
After coating the edges of your board with wax, make a random surface by spooning out gesso onto the board and spreading it out with your adhesive spreader.

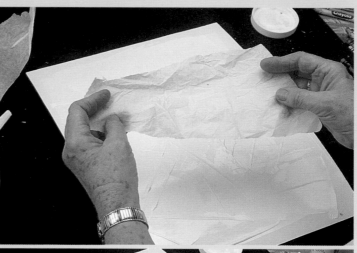

2: APPLY TISSUE
Crinkle and rip your tissue paper. Place it into the gessoed surface, layering it and leaving loose edges here and there. You don't have to cover the whole board. Try for one big shape, one midsize shape and some smaller shapes. Let the surface dry completely.

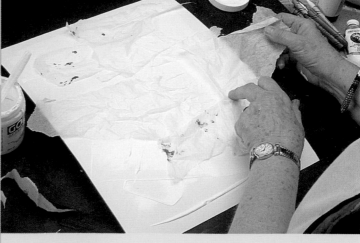

3: BEGIN PAINTING

Spend a few minutes looking at your surface from different angles to see which angle works best for your subject matter. When you have a design plan, load your brush with all three acrylics and wash across the surface.

4: MANIPULATE THE PAINT

Use clear water on the edges of your wash to encourage the paint to move and create the fragile look of flowers.

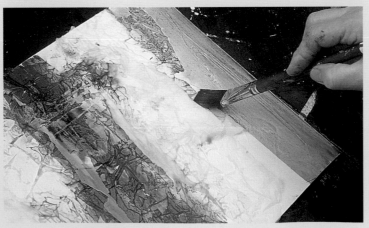

5: CHARGE IN MORE PAINT

Charge in additional washes of acrylic to further mix and work colors. Then use your watercolors to create another, more earthy wash, going back in with clean water to soften edges and create fragility.

6: Work on Design

Add new colors as needed to encourage your design and the flow of paint. Feature the textures of the paper, working slowly into the painting with detail. Make use of the washes you've already applied with clear water to encourage the fragile look.

7: Create Depth

Try applying flow enhancer in any dark, wet areas for an organic look. You can go in with more details as the paint dries, adding stems now for softer edges that sink to the background, or adding stems when dry for harder edges that come to the foreground.

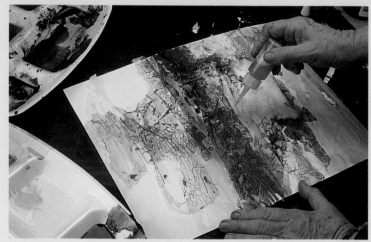

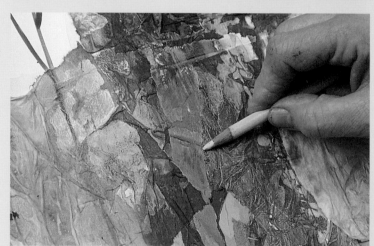

8: Add Colored Pencil Details

Use your colored pencil over certain areas to pull out the webbing of the tissue, imitating the organic features of the subject. Try using light-colored pencils over dark areas of paint with a "drybrush" technique to pick up tissue texture. Think all the while of creating a variety of shapes, balancing them and threading shapes and colors through the painting to divide up space and harmonize.

9: Add Final Touches

Use a graphite pencil to outline organic, lacy edges, connecting and creating new shapes.

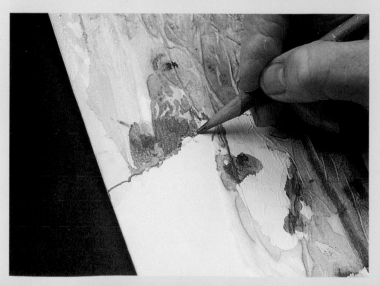

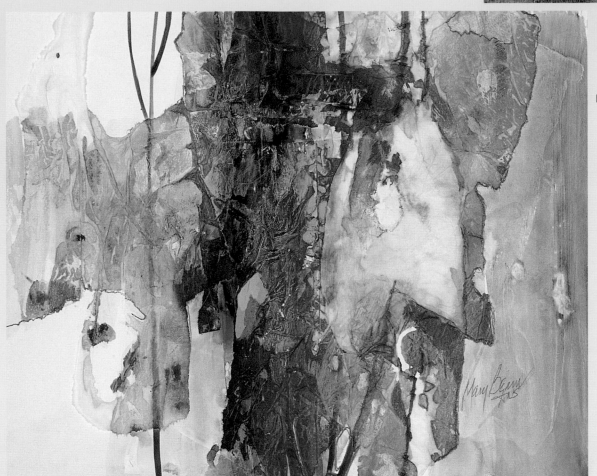

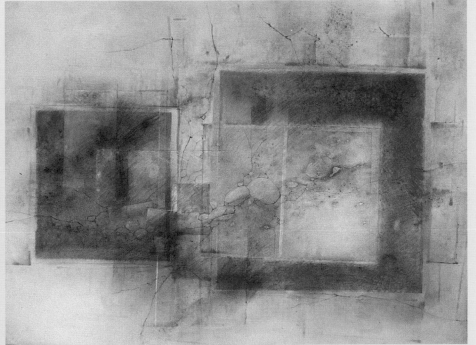

In Motion * *Peggy Brown* * *26"x40" (66cm x 102cm)*

Transparent watercolor and graphite on paper * *Collection of the artist*

DON'T TRAP YOUR CREATIVITY

Keep in mind the methods of the Navajo artists and Cubists: Start a line at the top of your painting and bring it all the way to the bottom and off the page to divide up the space. If your line doesn't go off the page, your creativity will be trapped in that painting for all time.

Navajo weavers extend a thread from out of their weaving so their creativity is not trapped.

Brown uses a monochromatic palette and subtle suggestions to convey her mood and ideas. This color scheme would work well with the tissue/rice paper technique.

Students' Tissue Florals

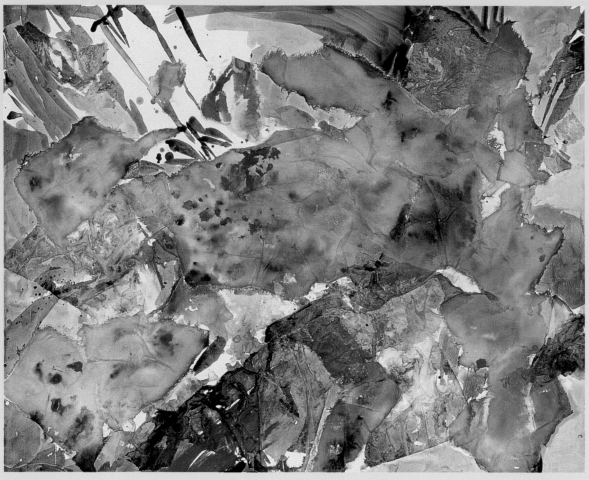

FINISHED TISSUE FLORAL ∗ *Libby Fellerhoff*

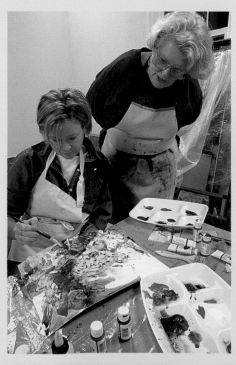

Mary gives tips to a workshop student.

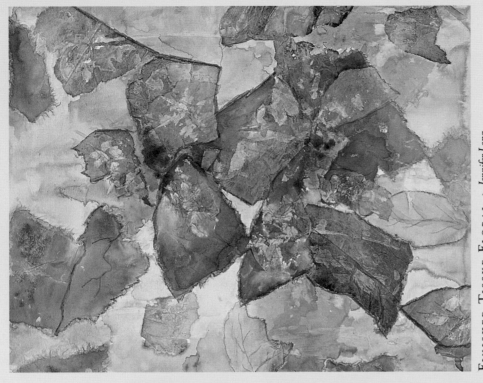

Finished Tissue Floral * *Jennifer Long*

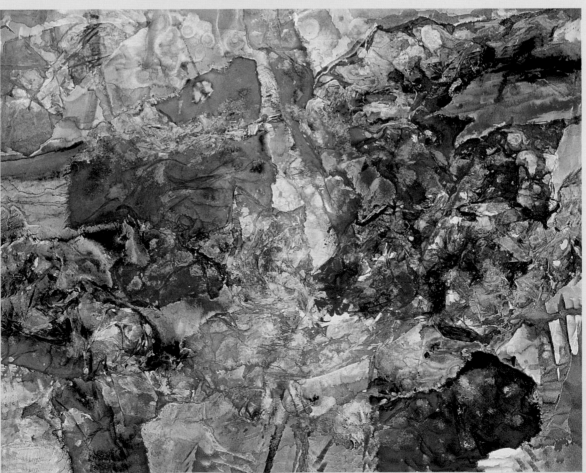

Finished Tissue Floral * *Amber Traven*

creating a MODELED GEL SURFACE

A modeled gel surface is fascinating to create and stimulates the imagination. Although you can paint with watercolors on gel, gel is married to acrylics via its polymer base, which gives the colors a vibrant intensity.

Gel can be manipulated into shapes and patterns before it dries. You can scratch it with a stiff brush, incise lines into it with a sharp instrument or create diverse flat and textured areas with the adhesive spreader—the list goes on. Consider ways to stamp into the surface using objects you find around the house, such as empty film cases. Jar lids make good circles, and cookie cutters are fun too. Put your imagination to work and become aware of items that would make interesting stampings, and I'm sure you will discover personal and unique ways of using this wonderful product. It's one of my favorite ways to personalize the underpainting.

MATERIALS LIST

Surface
Illustration board or watercolor paper

Brushes
1-inch (25mm) flat acrylic
3-inch (75mm) flat bristle

Paints
Fluid acrylics: Quinacridone Gold, Quinacridone Crimson, Turquoise (Phthalo)

Other
Gel medium (The heavier weights are best for this demo.)
Adhesive spreader
Various articles for incising, shaping and stamping
Charcoal

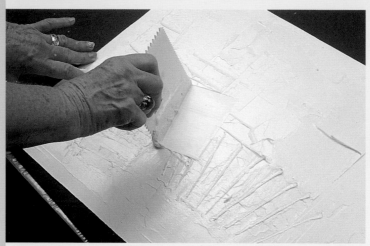

1: MANIPULATE THE GEL MEDIUM
Spread gel medium on your illustration board and draw patterns into it with the adhesive spreader. Keep the gel ⅛" (.32cm) thick or less. Search for nice shapes.

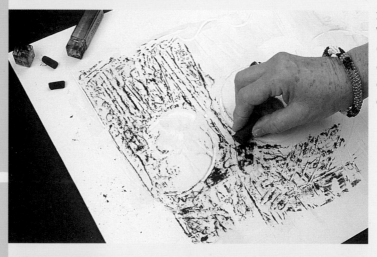

CREATE AN INTERESTING SURFACE
Concentrate on making an interesting and varied surface using your stamping materials and tools. Try imitating a panoramic view such as you'd see from the window of an airplane. Let dry.

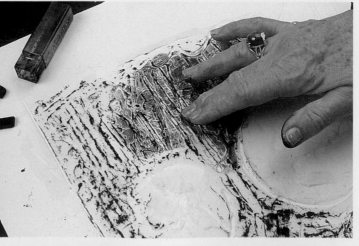

2: ENHANCE TEXTURE WITH CHARCOAL
Once your surface is completely dry, rub charcoal over the gel to enhance the textures.

Use your fingers to spread the charcoal or rub it into the surface.

3: ADD PAINT

Float acrylic washes over the surface. I start with Quinacridone Gold to see how it will react with the charcoal. The acrylics will run and flow over the gel surface.

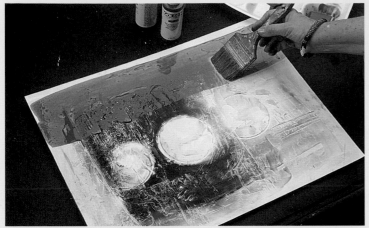

4: LET COLORS BLEND

Try to establish a dark underpainting, adding in red and blue for variety. When dry, define and bring out the design with opaque colors mixed with the colors you've used on the underpainting.

Modeling a gel surface sets up organic patterns that stir the imagination. You have not controlled or planned this surface, and many surprises await to challenge your creativity. Hopefully this surface will bring images to light that you have come across but have stored away or forgotten. This surface is always exciting to me because I know I'm in for an experience of discovery. Fun!

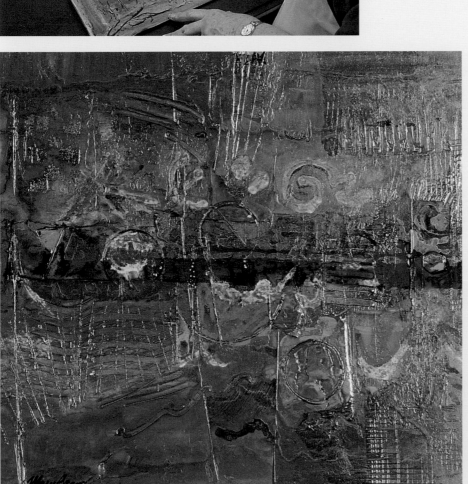

EARTH TIDES * *Mary Todd Beam* * *30"×40" (76cm×102cm)* * *Acrylic on gel* * *Collection of the artist*

building a SURFACE WITH GESSO, GEL *and* SAND

*V*ery early in my career I found that texture is the thing that interests me most. I wanted to find a way to use this interest in a personal way. I developed a process of defining space and creating a heavy texture on the same painting. This technique features edges and a variety of textures for the eye to move over.

MATERIALS LIST

Surface
Illustration board

Brush
l-inch (25mm) acrylic flat

Paints
Fluid acrylics: Turquoise (Phthalo), Quinacridone Gold, Quinacridone Crimson
Iridescent: Iridescent Pearl

Other
Adhesive spreader
Adhesive shelf liner (Con-Tact paper or a brand from your local grocery will work just fine.)
Soft drawing pencil
Sand (one cup from lumberyard or hardware store)
Gesso
Gel medium (Any weight will work; this demo uses heavy weight.)
Utility knife
Paper or Styrofoam cup
Sewing tool for cutting circles
Flow enhancer

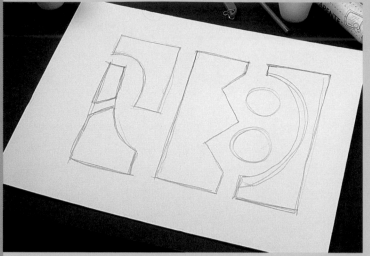

1: COMPLETE THE DRAWING
Draw three large windows or shapes on your board with a pencil. Fill in areas with smaller shapes. A good shape is where all the sides are different.

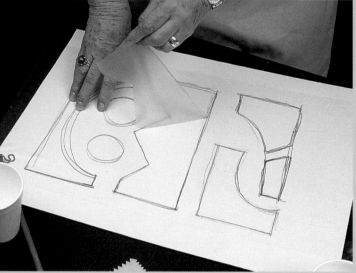

2: MASK WITH ADHESIVE SHELF LINER
Lay adhesive shelf liner over the design and smooth it down to remove any bubbles. Then cut the window shapes out of the adhesive liner with your utility knife or circle cutter and peel the windows from the board. Don't worry about cutting into the board—it can take a beating.

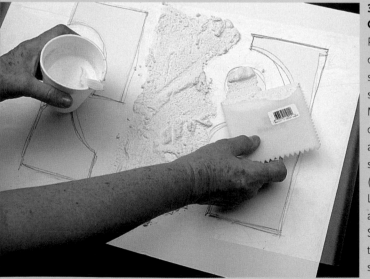

3: MIX AND APPLY GESSO AND SAND
Pour gesso into a paper cup and mix with ½ cup sand. Pour the mix over some of the shapes. Make sure the mix goes over the edge of the adhesive liner. Make sure the surface is ⅛" (.32cm) thick or less. Leave some areas rough and others smooth. Sculpt and make patterns with an adhesive spreader.

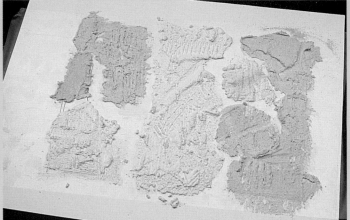

4: MIX AND APPLY GEL AND SAND

Do the same with gel and sand as done in step 3, mixing it and then spreading it on the surface and creating texture. This mix will be darker than the gesso/sand mix.

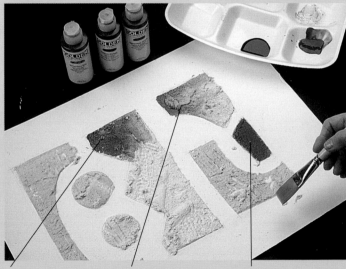

5: BRING BACK EDGES

Peel off the adhesive liner and let the sand mixes dry completely.

6: BEGIN PAINTING

Once the sand mixes dry, erase any pencil marks on your surface and chip off any stray sand flecks.

Paint your sand mixture with a variety of colors, creating a more natural look. You can blend over these initial colors with additional colors or with water to vary value. You can add iridescent colors over other colors when wet or dry.

Remember to look at the painting from different angles as you paint.

Quinacridone Gold mixed with Quinacridone Crimson

Quinacridone Gold

Quinacridone Crimson

COLORED TEXTURE

I like the natural colors of sand and collect sand from my travels. I have found black sand on some beaches; white sand on other beaches; and red, fine sand inland. Small ground-up shells are a good addition. Any dry substance can be used.

If you want to add color to your sand, you can either add paint to the sand mix first and then apply it to your surface, or apply the sand mix to your surface first and then wait till it dries and paint it.

7: ADD IRIDESCENT COLORS

Add Iridescent Pearl over colors to create a new effect. Feel free to mix another color over top of iridescents. Add water to change values.

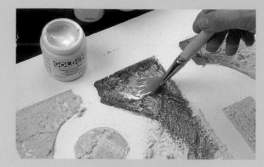
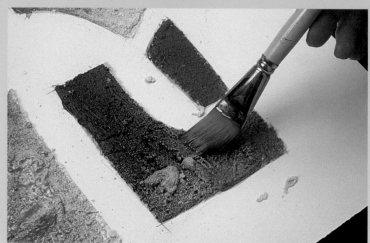

8: CREATE A MOSSY LOOK

Paint some blue, then Iridescent Pearl and then some water. Add gold on top of that. Using a flat brush will help you get the paint down into the texture of the sand mix.

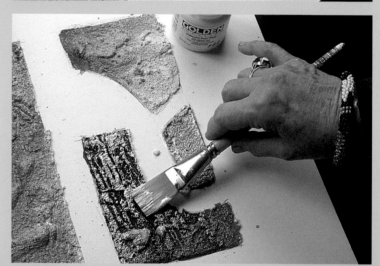

9: DRYBRUSH IRIDESCENTS

Use your flat brush with a thick consistency of Iridescent Pearl and drybrush over darker colors to bring texture back to that area and pick up accents.

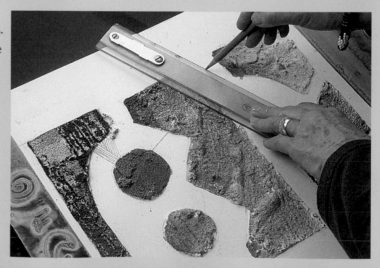

10: DEVELOP THE BACKGROUND

Try painting an acrylic border around the board, creating symbols with flow enhancer. Draw in graphite lines between sand shapes, to create a geometrical feel in the background. Add your own symbols and details to finish.

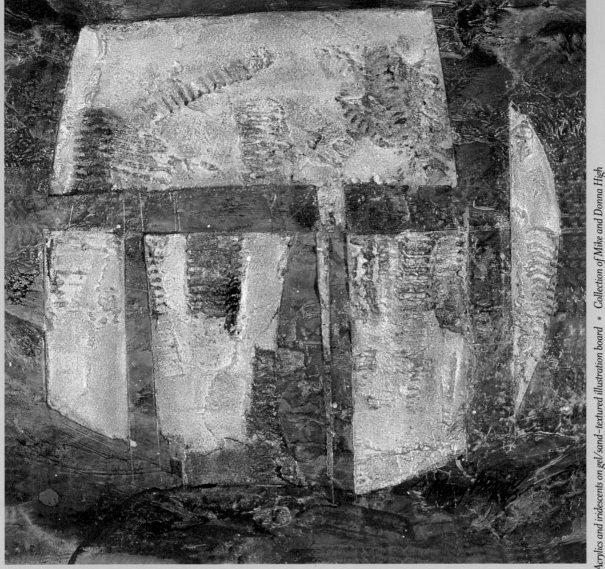

*Acrylics and iridescents on gel/sand-textured illustration board * Collection of Mike and Donna High*

ANCIENT THOUGHT * *Mary Todd Beam* * 20" × 22" (51cm × 56cm) *

A painting that is predominantly texture challenges the viewer. A textured painting tends to be read with the eye following the depth or thickness of each texture. Smooth textures contribute a resting place for the eye while providing a contrast for rougher textures.

"Creativity is the ability of a person to respond to visual and other sensory stimuli in an original way, and then to share this response with passion, individuality and spirit."

—Gerald Brommer

LEAD YOUR VIEWER

Leave your painting for awhile. When you return to view it, notice where your eye is drawn first. It may be a color, or it may be a textured passage. Be the conductor, leading the viewer's eye through your painting.

SEDONA MEMORIES · *Mary Todd Beam* · *24"×48" (61cm×122cm)* · *Acrylic on canvas* · *Collection of the artist*

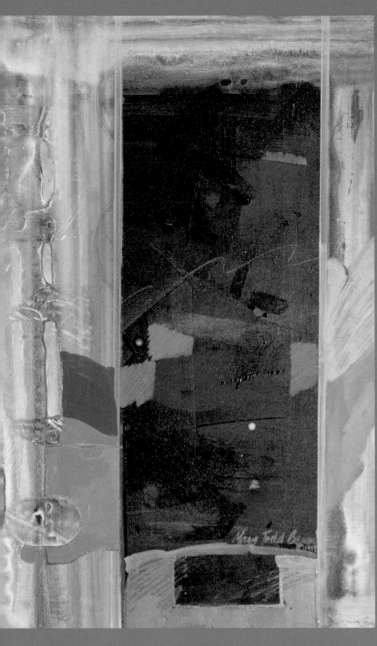

"Color is something only you can give to art." —Mary Todd Beam

How can I be creative with color? Aren't there scientific rules governing the use of color? Yes, but these rules were made to help the artist. They can be vital to the organization of the painting, but you are the creator, so your desires supersede the rules. To be creative you must tread a new path. During my career I've noticed that those whose works most interest me have come up with a personal color scheme. This scheme mirrors their personality.

Creating Your 3 Personal Palette

WHAT'S YOUR FAVORITE COLOR?

Does a limited palette suit your personality?

Visit a gallery. Which paintings have the color schemes you like best?

Do you have a certain color scheme running through your wardrobe?

Taking a Color Inventory

To develop your personal palette ask yourself: What is my favorite color? Do I particularly enjoy a certain color combination? What is my least favorite color? Do I ever include it in my work? Do I usually enjoy high-key or low-key schemes when viewing others' work? Use your answers as guides.

Browse through some art books and note which colors appeal to you. Build your color scheme around your likes. By stressing and exaggerating your likes in your work you will be painting in a more personal manner. This takes a degree of courage and some effort, but it will be quite satisfying when you find your colors. Try not to be swayed to the public's tastes. This is hard, but if you want to paint in a personal manner and find your creative route, then your own tastes must lead you.

KNOW YOUR COLORS

Basic color theory is essential for solving problems in your work. You need to know the dynamics of the color wheel and how to use complementary, analogous and triadic colors. These are vital to any artist who gets stuck in the midst of a painting and wonders what to do next. This knowledge can help you make the right choice for the next passage of color, but it shouldn't be a block to limit a creative decision. Your unique personal preferences should supersede any dictated rules. Become aware of your "likes" and then have the courage to express them.

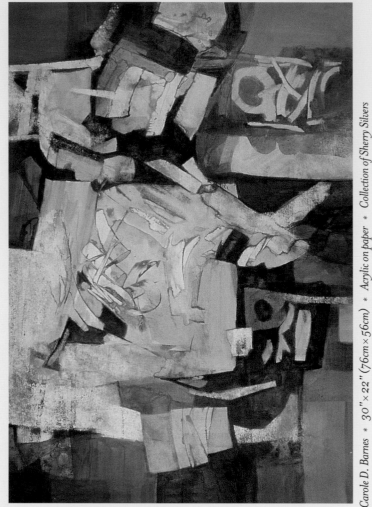

*Carole D. Barnes * 30" x 22" (76cm × 56cm) * Acrylic on paper * Collection of Sherry Silvers*

ANCIENT LANGUAGE *

Barnes uses a harmonious palette. She selects colors that complement each other and establishes a range of values that keep the eye moving through the painting.

TRANSFORMING COLOR

Underpaint an area or streak an area with Iridescent Pearl paint. When it dries, overpaint it with a transparent fluid acrylic. This will give you a vivid jewel tone or metallic look. The colors are startling!

—William H. McCall

Learning Your Paints' Properties

GLAZING

Fluid acrylics can be utilized to their greatest potential when using a glazing technique. Since the acrylics do not lift easily, they can become the bottom layer of the glaze. This layer will not change when dry or when another layer is painted over it.

Fluid acrylics are transparent and translucent, so they are naturals for the artist who wants to create a mixed color (without mixing) by layering these paints.

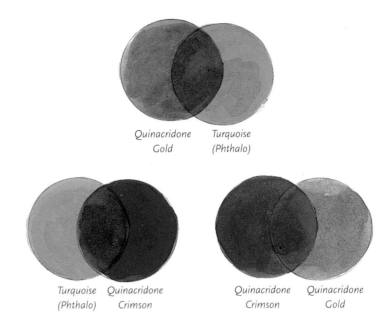

Quinacridone Gold *Turquoise (Phthalo)*

Turquoise (Phthalo) *Quinacridone Crimson*

Quinacridone Crimson *Quinacridone Gold*

Glazed Fluid Acrylics
Fluid acrylics lend themselves to glazing techniques. They can be applied transparently over other dry colors, and since they do not lift once they dry, this can give your painting an appealing glow.

Harmonizing Colors
This chart contains examples of many of the mixed color possibilities in my palette. Notice how they all harmonize. See if you can identify the tints, shades and transparent pieces.

DISPERSAL

Acrylics have a fine dispersal quality: "They travel well." Due to their thickness, the artist can make strong passages of paint on wet paper and the paint will bloom and move across the paper. This technique is especially effective when painting skies or large bodies of water. The intensity of the paint is affected when water is added, so the watercolorist can paint large areas of dynamic color.

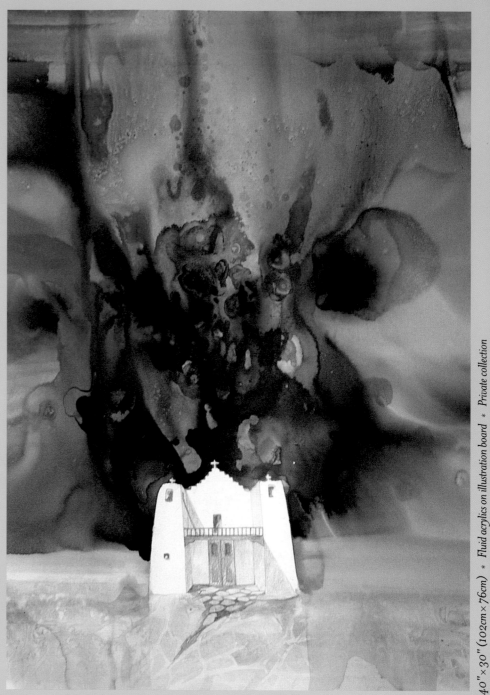

*40" × 30" (102cm × 76cm) * Fluid acrylics on illustration board * Private collection

KEEPER OF SOULS * *Mary Todd Beam* *

You can obtain a plentiful dispersal of paint with fluid acrylics. They move quite readily across a wet painting surface, without even using a flow enhancer. You can add flow enhancer to the paint or surface to cover larger areas. You can tilt the paper to move the color in different directions. The key is to begin with enough color to produce this effect.

OPAQUES

Fluid acrylics can be mixed with white and black gesso to create an opaque paint. When I limit my palette, I find that I can substitute three colors for the primaries and then develop a palette that will be harmonious. The same watermedia painting could contain areas of transparent washes, translucent glazes and opaque areas. Using opaques opens up the range of colors available to the watermedia painter. You can develop a personal palette that fulfills your unique aesthetic desires.

Quinacridone Gold + white gesso

blue + gold + white

gold + red + white

Making Tints With Paint

Tints are made by adding some white gesso to your paint. When you mix with white, you can vary the values of your color by the amount of white you add.

Turquoise (Phthalo) + white gesso

red + blue + white

Quinacridone Crimson + white gesso

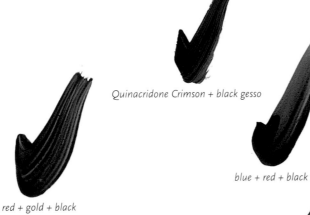

Quinacridone Crimson + black gesso

red + gold + black

blue + red + black

Making Shades With Paint

Shades are made by adding some black gesso to your paint. You can greatly extend the range of your colors by mixing some of the fluid acrylics with black gesso, and then adding in some white gesso. This adds more choices and sophisticated shades of color to your palette.

Quinacridone Gold + black gesso

gold + blue + black

Turquoise (Phthalo) + black gesso

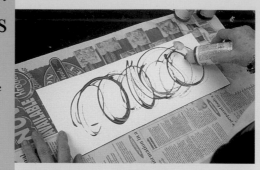

working with STAINING COLORS

Fluid acrylics are powerful stainers. I generally use three strong stainers [Quinacridone Gold, Quinacridone Crimson and Turquoise (Phthalo)] as my primary colors and stand-ins for yellow, red and blue. In this demonstration we will use an adhesive spreader to scrape through the paint, leaving the stains behind to tell a story. With this technique you can make some interesting patterns. Practice will help you develop the negative spaces and figures that tend to show themselves with this technique. You could also try to cover the paint with plastic to make different patterns and then scrape through, leaving some of the paint to produce positive and negative areas.

MATERIALS LIST

Surface
Illustration board (Try muslin, duck-cloth or canvas for different effects.)

Brush
1-inch (25mm) flat

Paints
Fluid acrylics: Quinacridone Gold, Quinacridone Crimson, Turquoise (Phthalo)

Other
Adhesive spreader
Newspaper (This gets messy!)

RANDOM-PATTERNED STAIN

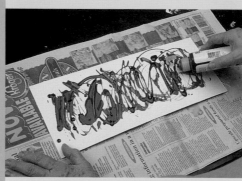

1: APPLY THE FIRST COLOR
Lay your illustration board on a sheet of newspaper (this can be a real messy technique). Draw on random shapes with Quinacridone Gold, using it straight from the bottle.

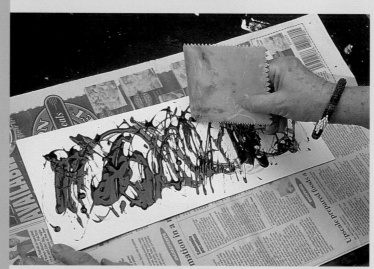

2: CONTINUE WITH THE NEXT COLORS
Apply Quinacridone Crimson and Turquoise (Phthalo) in the same manner as in step 1.

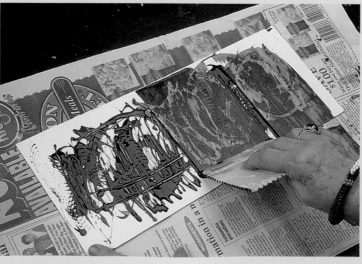

3: DRAW WITH YOUR SPREADER
Draw into the paint with the edge of your adhesive spreader, concentrating on random shapes.

4: SCRAPE PAINT AWAY
While the paint is still wet, use the adhesive spreader (flat side) to scrape the paint off the surface, going from top to bottom. Let dry.

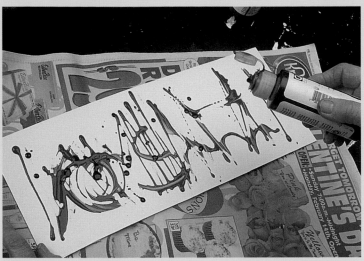

1: APPLY COLORS

Lay your illustration board on a sheet of newspaper. Draw shapes onto your board with Quinacridone Gold straight from the bottle, making some shapes tall and slender and others shorter and rounder. Sprinkle in Turquoise (Phthalo) dots.

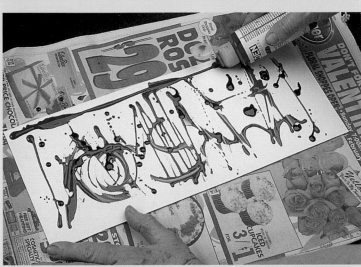

2: ADD BACKGROUND COLOR

Draw a Quinacridone Crimson line across the top of your board.

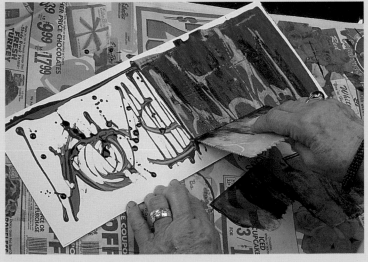

3: SCRAPE PAINT AWAY

Scrape the paint down from the top to the bottom of your board using the flat side of your spreader. The red will drag through the entire paper, pulling the gold and blue into figure-like shapes. Be sure not to overlap scrapes so you can get a smooth figure pattern all the way across the board. Let dry.

1: LAY ON THICK PAINT

Lay your illustration board on newspaper. Lay Quinacridone Gold, Turquoise (Phthalo) and Quinacridone Crimson paint on thickly.

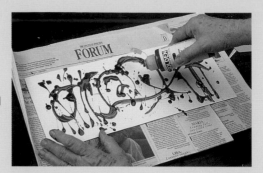

2: MOVE PAINT AROUND

You can use a wet brush to move paint around a little and help create figures. Anywhere you move the paint it will stain the board. Keep the paint thick.

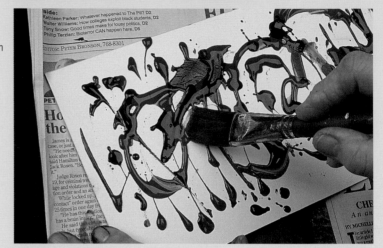

3: SCRAPE PATTERNS INTO PAINT

Use your spreader to move the paint into ladder patterns.

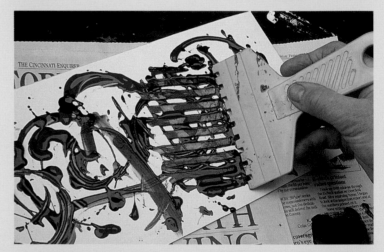

4: ADD MORE TEXTURE

Draw new designs with the end of the brush or use the flat end of the spreader to scrape parts of the painting down, leaving ladders intact on most of the painting. Let dry.

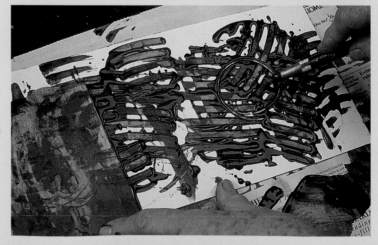

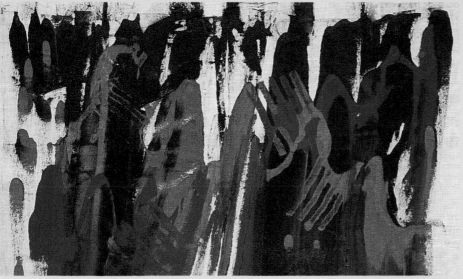

RANDOM STAIN ON MUSLIN * *Jennifer Long*

Random-Patterned Stain on Muslin
Try scraping away only parts of the paint with the adhesive spreader to add interesting shapes. Try to scrape down paint randomly, in different widths, so the color is varied all the way across the surface.

This fabric works well as a patch. Try sewing your staining on a pillow, art bag or T-shirt. It's "Wearable Art."

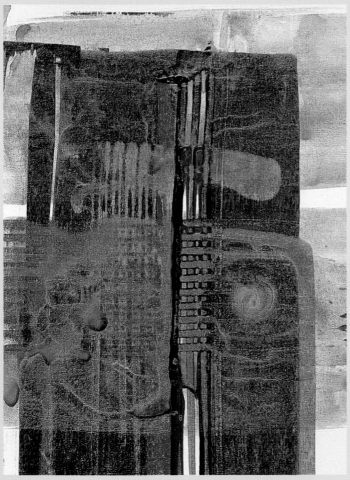

LADDER STAIN ON CANVAS * *Mary Todd Beam*

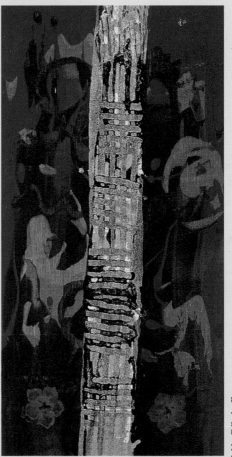

Ladder-Patterned Stain on Canvas
A random-patterned stain was completed on each side of the fabric. The center strip was painted on thicker and patterned into "ladders." When the ladders dried, the student floated Iridescent Bronze paint over the pattern and applied some stamping for added interest.

LADDER STAIN ON CANVAS * *Libby Fellerhoff*

Ladder-Patterned Stain on Canvas
Floating wide bands of iridescence across your stained pattern creates an interesting composition that enhances the effects of the ladders.

Green will settle out of the Iridescent Bronze. This can be left on for interest, or lifted out gently with a paper towel.

47

One of the most important features in your painting is the design. An otherwise good painting may fall apart due to a lack of knowledge about design. There are classical design formulas that may still be present in contemporary work, but new styles and designs have developed in modern art. These classic and modern *formats* can be combined to produce new formulas for design.

By following a plan or layout, you can assemble the devices in your painting in a more dynamic format that will contain stronger impact and thereby communicate with your viewer in a more direct manner.

4 Streamlining Your Design

WHAT IS YOUR PAINTING SAYING?

Can you look at your painting and determine what one thing you're trying to say in it? How can you exaggerate that one thing for visual effect? Sometimes all you have to do is shift the design: move the horizon down, turn the paper around, etc.

ROCK OF AGES (DETAIL) ∗ *Mary Todd Beam* ∗ *30"×40" (76cm×102cm)* ∗ *Acrylic and watercolor on gesso* ∗ *Private collection*

Strengthening Your Design

One day, while I was sitting at the feet of my teacher, Edgar Whitney, he looked at me and said, "You think you are designing that painting; no, you're designing your life, choosing what you will make part of your life and what you will not do." Paintings bring your ideas and emotions to life. They give viewers an invitation into your world. Let your design guide them through your world, by keeping the following tips in mind.

1. Exaggeration and simplification go hand in hand. Is there an element in the painting you can exaggerate to strengthen your design? Can you eliminate part of the painting and make it say more?

2. Can you clarify your intent? What was the initial inspiration? Can you say it in one or two words?

3. Can you direct the viewer's eye through the painting by creating interesting edges or patterns?

4. Can you shift the horizon or change the design format to make a stronger statement?

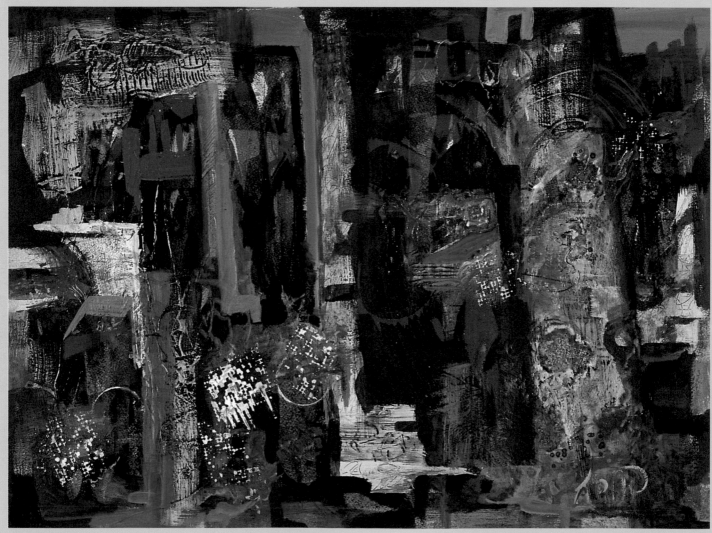

A carefully chosen palette has become part of this design. Since texture is the featured element, the design must be carefully executed. Eye movement is designed to keep the viewer in the painting.

AFTERMATH * *Ganga Duleep* * 22"×30" (56cm×76cm)

*Acrylic on paper * Collection of Wall St. Associates*

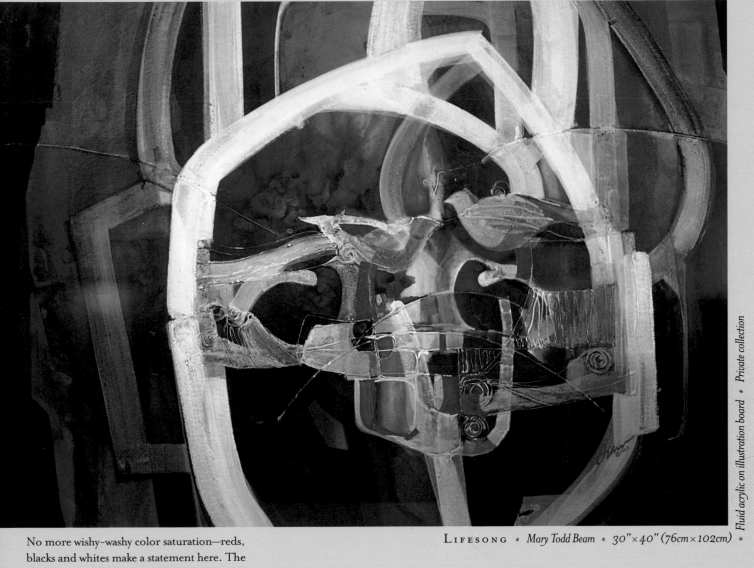

No more wishy-washy color saturation—reds, blacks and whites make a statement here. The white stripes contain and frame the center of interest, helping the viewer find the area of main focus.

LIFESONG * *Mary Todd Beam* * *30"×40" (76cm×102cm)* * *Fluid acrylic on illustration board* * *Private collection*

"Perfect design is boring, too predictable. Taking some risks gives the painting a personal touch."

—*Mary Todd Beam*

High Horizon Vertical

This design format represents height in the subject, such as a high mountain, high trees or tall buildings.

PRIMORDIAL TRANSITION * *Marilyn Hughey Phillis* * 29"×14" (75cm×37cm) * *Acrylic collage* * *Collection of Ohio University, Lancaster*

High Horizon Horizontal

A wide horizon talks about vastness: a
desert scene or a distant vista—anything
suggesting width.

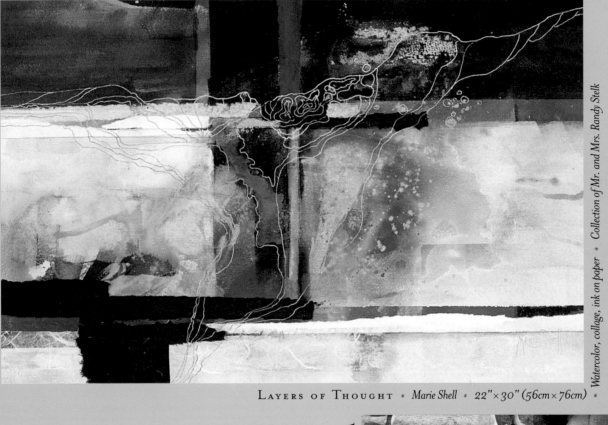

LAYERS OF THOUGHT * *Marie Shell* * 22"×30" (56cm×76cm) * *Watercolor, collage, ink on paper* * *Collection of Mr. and Mrs. Randy Stelk*

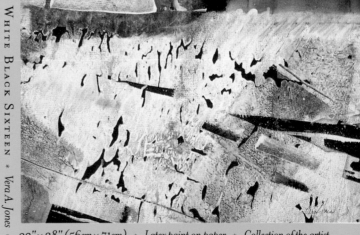

WHITE BLACK SIXTEEN * *Vera A. Jones* * 22"×28" (56cm×71cm) * *Latex paint on paper* * *Collection of the artist*

Low Horizon Vertical

This format is a real eye-catcher. It directs the viewer's eye to the point of interest while giving it a resting place in the nondominant section of the painting.

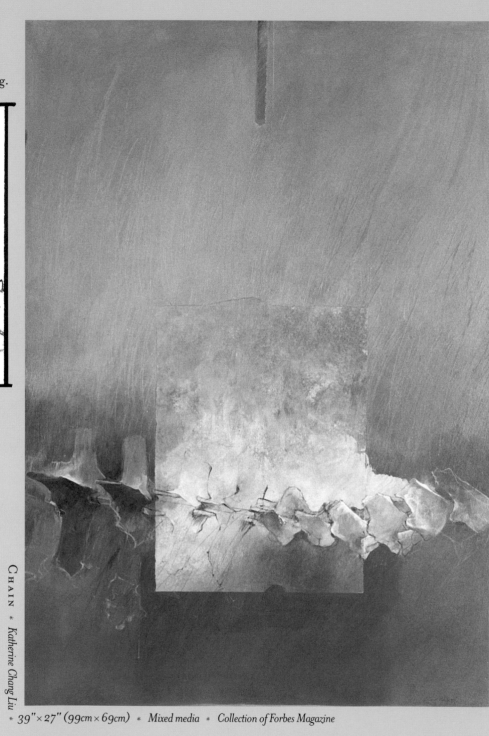

CHAIN * *Katherine Chang Liu*

* *39"×27" (99cm × 69cm)* * *Mixed media* * *Collection of Forbes Magazine*

Low Horizon Horizontal

This is an interesting way to display a still life or any subject that you would like the viewer to read the tops of, such as a series of rooftops or the top edges of an arrangement of objects in a still life. An interesting point in a painting is where the earth or subject meets the sky.

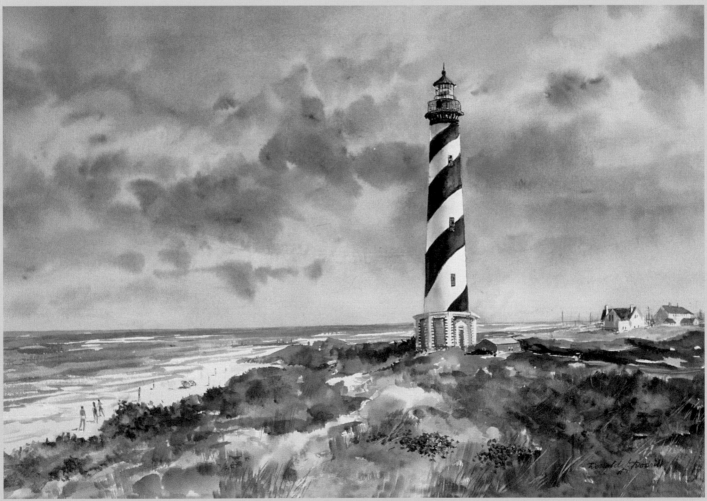

CAPE HATTERAS LIGHT * *Donald L. Dodrill* * *15"×22" (38cm×56cm)* * *Transparent watercolor on paper* * *Collection of Jon Raymond Dodrill*

The "S" or "Z" Curve

The use of curves is a traditional compositional device for leading the eye through the painting in a systematic manner. First applied to standing figures in gothic art, this device is now used widely by painters as a forceful design element.

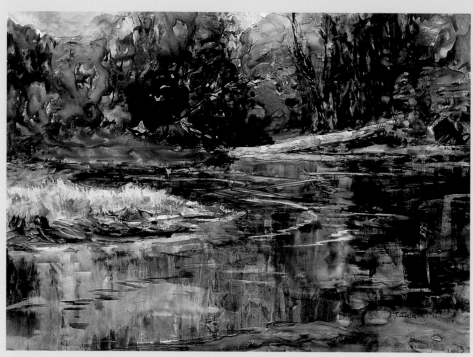

UP RIVER * *Taylor Ikin* * *18"×25" (46cm×64cm)* * *Watercolor on Yupo* * *Private collection*

OFF TO SEE THE WIZARD * *Fanchon c Gerstenberg* *

25"×20" (65cm×51cm) * *Watercolor, fabric and paper* * *Collection of the artist*

The Grid

Contemporary masters find this design intriguing. Colorists using color and content find this is a good marriage between color and abstract features. The grid is based on a play on "squares."

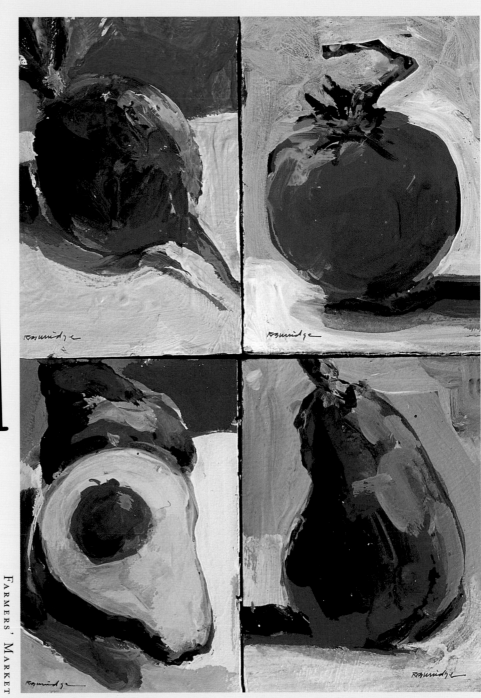

FARMERS' MARKET

* *Robert Burridge* * *14"×10" (36cm×25cm)* * *Aquamedia mix on paper* * *Collection of Dr. Karen Kolba*

Circular

Based upon a play on "circles," most of the subject matter or abstract elements are represented by, or can be reduced to, circles. The painting is most resolved when one or more circles extend beyond the picture plane.

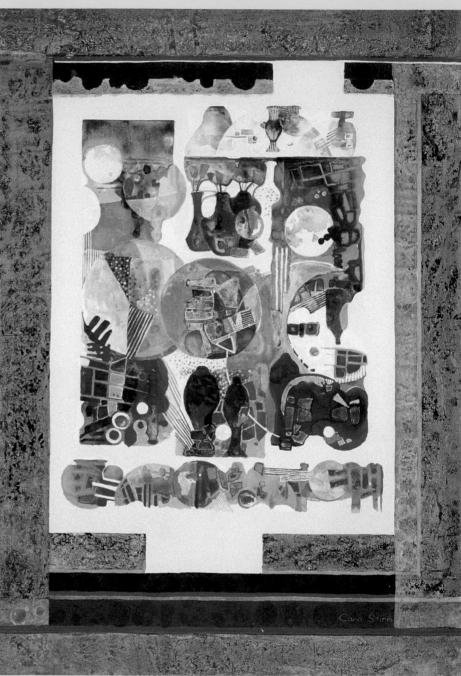

FRAGILE OPTIMISM * *Cara Stirn*

* *30" × 22" (76cm × 56cm)* * *Inks on paper* * *Collection of the artist*

Cruciform

This strong design format is a pleasant way to build a composition and lead the eye through the painting in an orderly manner. It is based upon "squares," with the squares extending beyond the picture plane.

VORTEX DREAMS * *Juanita Williams* * *40"×30" (102cm×76cm)*
* *Mixed watermedia on illustration board* * *Collection of the artist*

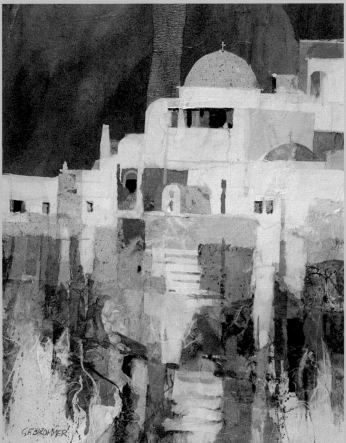

SANTORINI IMPRESSION * *Gerald F. Brommer*
15"×11" (38cm×28cm) * *Gouache, watercolor, collage* * *Private collection*

Strata

If you turn the letter "I" 90 degrees, you will see a horizontal format that was popular when artists were painting stripes. Now it's called the *strata format*. This design works well with paintings that feature geological formations and layers of any type. It is extremely popular now with painters who want to make metaphors about time or the aging process.

LAYERING

Look around to see where you can spot layers. Have you thought about layering stages of your life, experiences, etc.? There is a society called the Society of Layerists in Multi-Media that encourages artists who work in this manner. Their address is included in the back of this book, page 142.

COPPER CANYON (DESERT SERIES) * *William H. McCall* * 30"×22" (76cm×56cm) * *Mixed media* * *Collection of the artist*

Triangular

Can you reduce your subject matter to geometric shapes? Try triangles! Triangular formats work well with subjects that have sharp edges or that are rocklike in appearance.

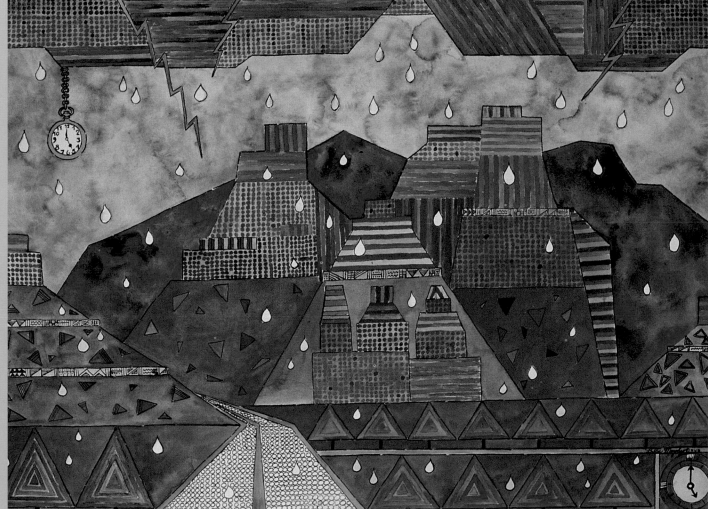

STORM TIME OVER SEDONA * *Billie B. Murphy* * 26"×36" (67cm×93cm) * Watercolor * *Private collection*

Seeing With Abstract Eyes

I'm always surprised that so many of my students are afraid of the word *abstract*. Abstraction is actually a tool for artists: It can be the best way to improve the dynamics of your work.

Most excellent works of art have an abstract base. They may be presented as representational, but when you squint your eyes you see that the artist has considered the impact of geometric abstract shapes when she built and planned her design.

Learning to see with abstract eyes can open the mind. It will help you analyze your work and resolve any difficulties.

Abstract is often confused with Non-Objective. Abstract starts with realism and simplifies the subject by reducing it to its basic geometric shape: An apple becomes a circle, a box becomes a square. Non-objective means no object was used. Paintings done this way have no reference to a subject or an object.

To a degree all art is abstract—the more the artist analyzes and intellectualizes the work, the more abstract it becomes.

AID IN ABSTRACT SEEING

Cut a fairly complex photo from a magazine or find one of your own photos. Enlarge it and make a copy of it.

Use a pen to outline the abstract positive shapes. Then look for the negative shapes and outline them.

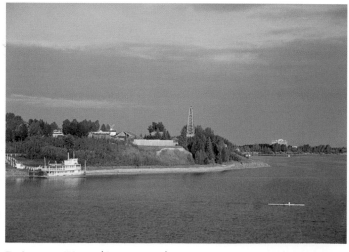

Reference Photo (distant view)

Photo by Sharon Williams

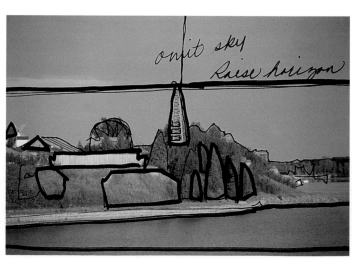

Reference Photo (focused in on subject)

Photo by Sharon Williams

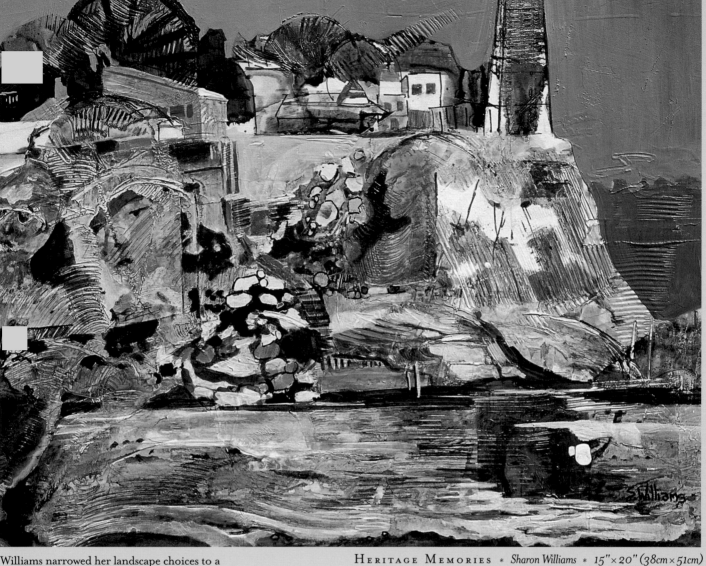

Acrylic on illustration board * *Collection of the artist*

HERITAGE MEMORIES * *Sharon Williams* * 15" × 20" (38cm × 51cm) *

Williams narrowed her landscape choices to a certain area and photographed it. She then identified and outlined the abstract shapes, remembering that the negative shape is abstract as well (see facing page). Once she identified the shapes, she rearranged them to create a more pleasing path for the eye and to balance the design. This same process works just as well for still lifes, figures or abstract art.

COMBINING DESIGN FORMATS

The design formats may be combined in a single painting, often resulting in complex but intriguing patterns. We are so fortunate to be living in a time when art is a plastic phenomenon, growing and changing, allowing us to be co-creators in unlimited challenges.

MOUNTAIN STREAM MEDLEY * *Mary Todd Beam* * *30"×40" (76cm×102cm)* * *Acrylic on illustration board* * *Collection of the artist*

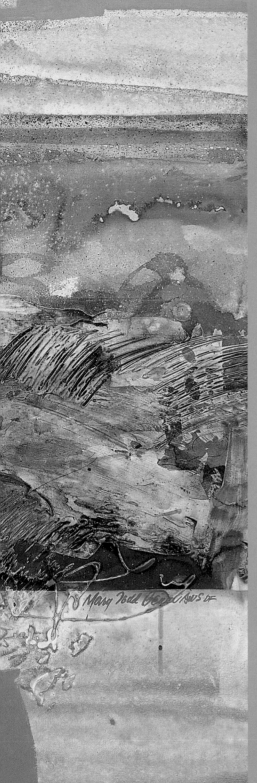

Mary Todd Beam? DF

Somewhere buried deep in our instinct are responses to the natural elements that surround us. Since we ourselves are composed of these elements, they become important to us in our mythic make-up. The elements that I'm most interested in, and that I want to discuss in this book, are light, water and earth.

Primitive man was very conscious of the importance of elements. The ancient Native Americans devised symbols to represent them. We as modern searchers for means of expression sometimes overlook the symbolic value of elements in dealing with modern subject matter.

Discovering Your Connection to Nature 5

TRANSLATING AN IMAGE

Here's a tip to help you gather your visual images: Remember always to simplify, exaggerate and resolve.

Observing Natural Patterns

Nature expresses herself through forms, patterns and shapes. She repeats these elements over and over in different substances. We see branching lines in leaves, human veins, crystals and feathers alike. We see spirals in snail shells and cosmic nebulae.

Artists, as observers, can become familiar with these forms and patterns and incorporate them into their work to capture organic effects.

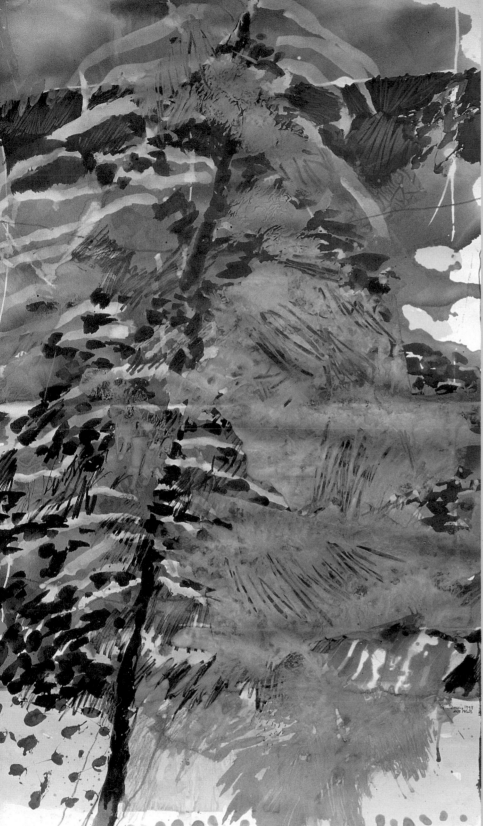

TAKE A WALK

Take a walk in the woods or by the seashore and write down or sketch all the designs of nature that you can find. Think of how you can imitate these stylized forms in your work.

The Treeness of It All * *Pat San Soucie* * 40" × 28" (102cm × 71cm) * Watercolor and gouache on hot press paper * *Collection of the artist*

San Soucie looks for contrasts and opposing elements in a painting. Her use of transparent, poured texture right up against thicker, blobbier gouaches adds visual piquancy that reads as excitingly promising.

capturing
NATURE'S MAZE

One of the functions of the artist is to create chaos, and then to find order and resolve that chaos. In this demo, the maze becomes the chaos. You will add order by painting, drawing or lifting.

1: LAY PAINT
Wet your paper with a 2-inch (51mm) bristle or sponge brush. Lay down large, juicy earth-toned washes of thick, rich pigment. Allow blooms to occur with the watery surface, bringing interest to your layer of paint.

2: COVER WITH PLASTIC
Lay plastic wrap over the paint and let the plastic naturally print into the paper. Each weight of plastic will give you a different print. Experiment to see which you like the best. Let paint dry.

3: REMOVE PLASTIC
When paint is dry, remove the plastic to reveal the pattern. Turn the painting around to study the design and determine a direction to take to add details and complete the painting.

LIFTING
Wet a sponge brush and lift paint here and there to show variety or to accent your design.

MATERIALS LIST

Surface
Illustration board

Brushes
2-inch (51mm) bristle
1-inch (25mm) flat
Sponge brushes

Paints
Watercolors: Alizarin Crimson, Burnt
 Sienna, Yellow Ochre, Phthalo Blue

Other
Plastic wrap
Graphite and colored pencils

CREATING NEW SHAPES
Use a wet flat brush to lift out organic shapes, blotting up excess water with a paper towel.
 Shape areas with opaques to describe the shapes you've chosen to feature.

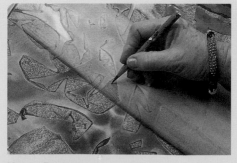

USING PENCILS
Use your graphite or colored pencils to define the details of the leaves, twigs or other shapes you find in your design.

BUILDING ROCKS

Painting rocks is a way to establish a focus and explore the surface, shapes and details found in this little cosmos. When you study rocks you will find abstract shapes, muted colors and a variety of textures.

Rocks present the viewer with a metaphor for strength, security and a connection to nature. They can become a powerful subject when used this way.

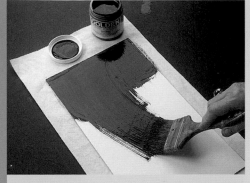

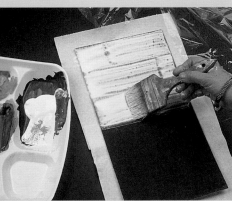

1: CREATE A DARK SURFACE

Mix a small amount of Turquoise (Phthalo) with black gesso for a cool color, or some Quinacridone Crimson with black gesso for a warmer shade of black, and cover the entire board. Let dry.

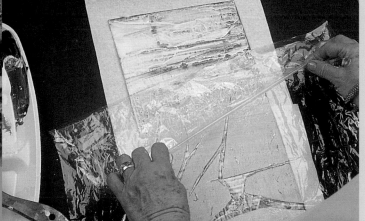

2: COVER WITH A LIGHT COLOR

Thin your white gesso to a creamy consistency and cover the board with it.

3: IMPRINT WITH PLASTIC

Place a piece of plastic wrap on the gesso and then slowly peel it back while the paint is still wet, stopping at intervals to create hard lines.

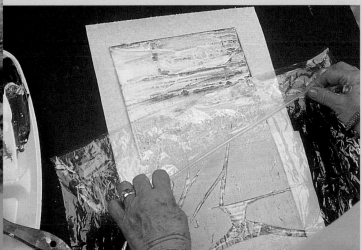

4: LAYERED TEXTURE

When the plastic is removed it will leave an imprint similar to the texture and striations of rocks.

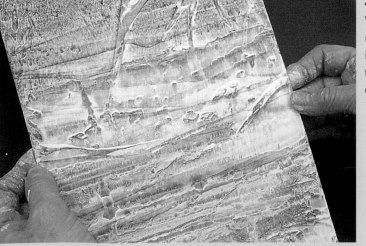

MATERIALS LIST

Surface
Illustration board

Brush
3-inch (76mm) bristle

Paint
Fluid acrylics: Turquoise (Phthalo),
 Quinacridone Crimson

Other
Plastic wrap
White and black gesso

Portraying Precipitation

Some of us are drawn to water as the medium of choice when we paint. We like its spontaneity, fluidity, transparency and brilliance when it combines with pigment.

Think also about its symbolic value. From ancient texts we learn that water was used as a symbol of purification: a washing away of the old and an induction into a new or better way of life. When water becomes a fountain or river, it takes on more power and meaning, such as a "river of life" or the "fountain of youth." Streams and rivers have been compared to the veins in our bodies, bringing or flowing the life force throughout the earth.

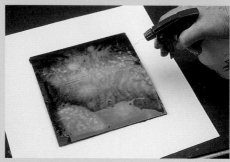

Water
Coat illustration board with thick, juicy paint and spray water into it before the paint dries.

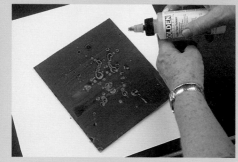

Flow Enhancer
Coat illustration board with thick, juicy paint and fleck flow enhancer into the paint as it dries. Try for small flecks.

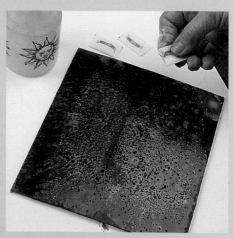

Salt
Coat illustration board with thick, juicy paint. Sprinkle with salt as the paint dries. Let the paint dry completely and then brush off the salt.

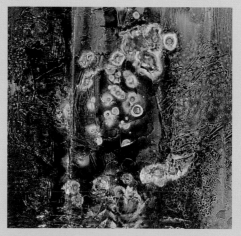

Precipitation on Gelled Board
Coat illustration board with gel and let dry. Then paint on a thick, juicy wash of color and try different effects such as (left to right) water, flow enhancer and salt.

Precipitation on Yupo
Coat Yupo with thick, juicy paint and try different effects such as (left to right) water, flow enhancer and salt.

Portraying Sedimentation

We can mimic the process of sedimentation by washing paint over a textured surface and allowing it to settle. I call this a *float*. The paint is "floating" over the surface off the brush. Executing a float demands a painting skill that encourages the painter to use more water and more paint, thus achieving a painterly effect. This technique is valuable for several reasons. It can be used to vary values, to represent fog or mist, or as a unifying element going across the painting from side to side.

Floating Acrylic and Watercolor
Mix a lot of water into your pigment to get a thick, juicy wash of color. Use a big brush to get a large stroke of color with lots of sedimentary action. Coating your surface with gel, texturing it and letting it dry will give you an interesting surface to work with.

The blue acrylic at the top deposits some darker color into the valleys of the texture, but the brown watercolor at the bottom works better, really picking up the texture of the surface.

Floating Iridescents and Interference Paints
You can mix and float iridescent and interference colors over texture for sparkling effects. Here, Interference Violet, Iridescent Bronze and Iridescent Pearl (left to right) have been floated over various textures.

TIPS ON FLOATING

Use one stroke: Don't go back over a float. This technique works best on textured surfaces, dark over light or light over dark. Use to unify or change the values of your painting. If an interference paint is floated thick enough it will produce a hologram effect.

painting the FOREST FLOOR

Y ou can sharpen your painting skills by delving into your imagination for images. Take your viewfinder out to the woods to gain ideas for design and to block out extraneous material from your image of the forest floor.

The forest floor or decaying matter can become a metaphor for the passage of time. Nature uses her painting skills of precipitation, sedimentation and erosion, and we can become a part of her creative process through imitation.

We will use adhesive shelf liner, lifting, printing and floating to create depth.

MATERIALS LIST

Surface
Illustration board or watercolor paper

Brushes
Foam brush
Large and small flats

Paints
Watercolors: Yellow Ochre, Burnt Sienna, Alizarin Crimson, Phthalo Blue
Fluid acrylics: Quinacridone Gold

Other
Gesso
Adhesive shelf liner (Con-Tact paper or a brand from your local grocery will work just fine.)
Scissors
Wax
Graphite and colored pencils
Stamps
Flow enhancer
Heavy- and light-weight plastic wrap

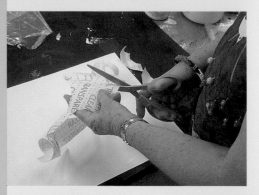

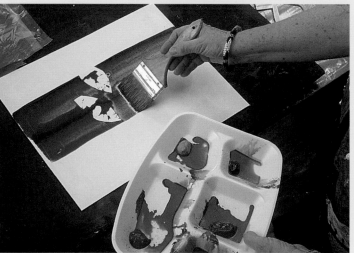

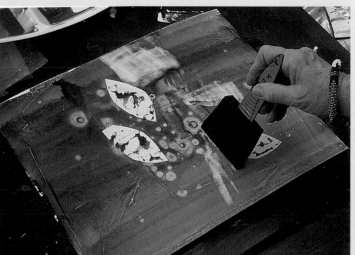

PAINTING A TINY ECOSYSTEM

Think of this view of the area at your feet as a small world in itself. Where are the actors? Make it a varied view: soft edges against hard, and smooth against rough, changing color and value.

1: PREPARE SURFACE AND APPLY SHAPES
Wax the edges of your board or watercolor paper to avoid paint seepage, and apply a rough and organic gesso surface, leaving in drips and scrapes as they fall. Let dry. Cut out simple leaf shapes from your adhesive shelf liner and stick them on the surface. This will be the lightest value, and we will work to create the illusion of looking through layers of debris.

2: CREATE THE "MUD"
Make mud using your sedimentary watercolors. You can include some staining colors, but keep them to a minimum.

Float large, flat washes over the board using a nice thick coat of paint. You can use a mixture of Burnt Sienna with a small amount of blue to give a darker brown.

3: STIR UP THE SURFACE
Fleck on flow enhancer to create a small amount of precipitation.

A bear comes along and kicks up some leaves, so use your lifting techniques. Lift out sticks that run clear through the whole painting.

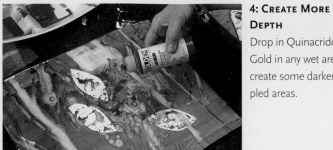

4: CREATE MORE DEPTH

Drop in Quinacridone Gold in any wet areas to create some darker dappled areas.

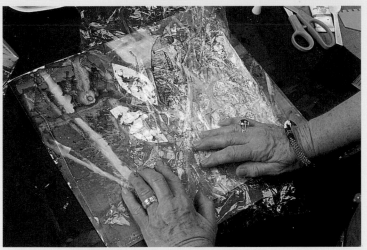

5: APPLY PLASTIC

Cut a leaf out of your heavier weight plastic and lay it in the wet areas of the painting to create yet another dimension.

Cut a piece of light-weight plastic and crumple it. Lay it into your wet painting. Allow it to dry.

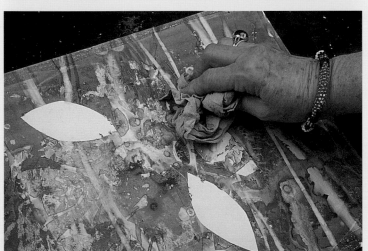

6: LIFT OFF PLASTIC AND PREPARE SURFACE FOR MORE PAINT

Once the paint has dried, you can lift off the plastic sheets and adhesive shelf liner. If you have an adhesive liner shape you'd like to leave in place, feel free.

Use a brush and clean water to go back into the painting and lift out any additional stick shapes, blotting with a paper towel as you go. The paint lifts easily from the gessoed surface.

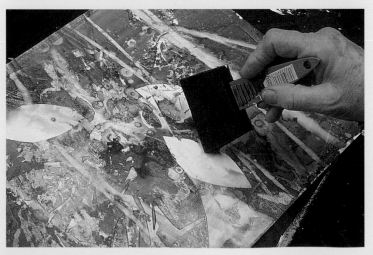

7: SOFTEN WHITES

Use your wet foam brush to soften the harsh white of the leaves by painting water around the leaf edges and loosening the color.

8: ADD COLOR TO LEAVES

Use Quinacridone Gold to add some thin washes of color to the white leaves. These leaves should be the most realistic part of the forest floor. They represent the top layer.

Use the painting-around technique (see page 14) with Quinacridone Gold to create more natural shapes and earthy colors. Try to make all the whites a different value.

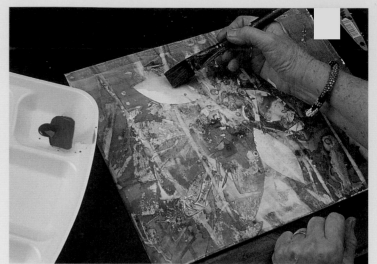

9: ADD FINAL DETAILS

Go in with your watercolors to bring out other colors. Try blue leaves to complement the orange floor. When your leaves dry, go in with graphite or colored pencils and detail the leaves, emphasizing their hard edges so they show as the top layer of the painting.

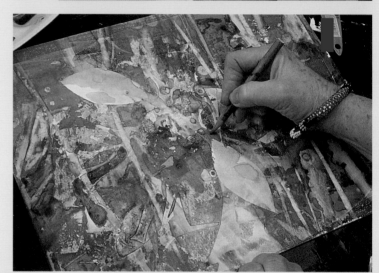

SPATTER ON TEXTURE

Load an old toothbrush with paint and pull a credit card along the bristles, spattering texture onto your painting. Practice on scrap paper first until you find the right effects. This can be the finishing touch, creating unity in your design.

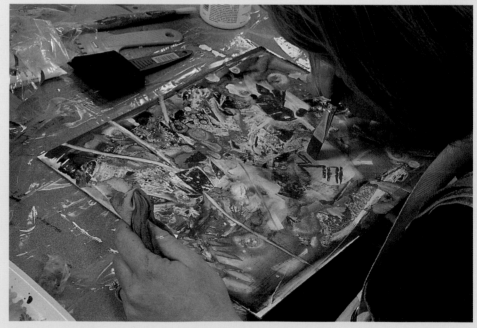

Student at Work

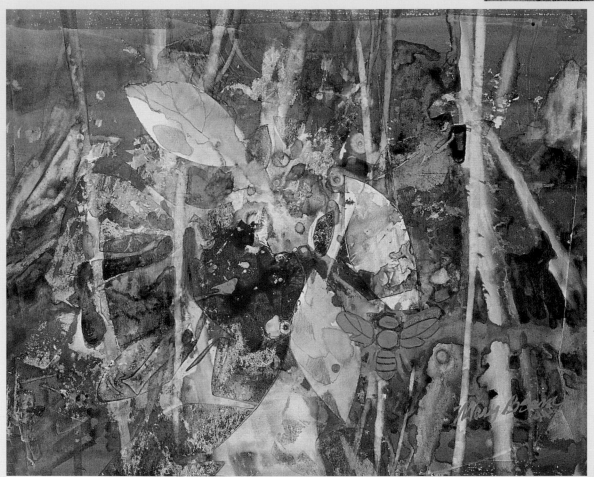

I stamp on a bumble bee to add yet another layer to this painting, creating more depth.

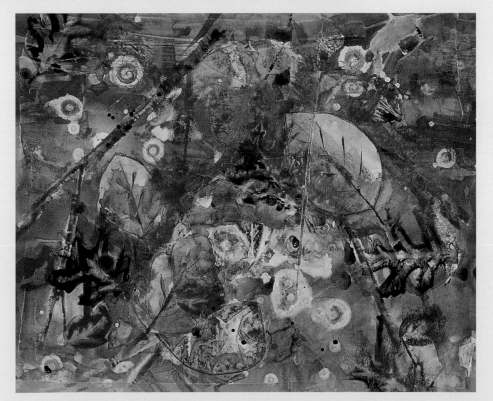

FOREST FLOOR * *Jennifer Long*

creating a
MOUNTAINSCAPE

Mountains suggest a strata or "S"-curve design layout. The eye should zigzag through the painting, settling on soft areas and being led by harder edged areas.

Mountains represent strength, power and serenity. We can make these messages stronger if we paint the mountain using a high-horizontal format.

Create surface texture in your mountains to give the feel of the landscape, which can be enhanced by the sedimentary quality of the paint, giving a rough, earthy feel to your painting.

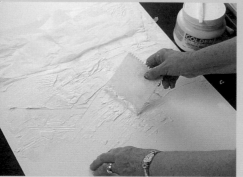

MATERIALS LIST

Surface
Illustration board or watercolor paper

Brushes
Foam brush
Large and small flats

Paints
Watercolors: Yellow Ochre, Burnt Sienna, Alizarin Crimson, Phthalo Blue
Fluid acrylics: Turquoise (Phthalo), Quinacridone Crimson, Quinacridone Gold

Other
White and black gesso
Gel medium
Tissue or rice paper
Flow enhancer

1: PREPARE THE SURFACE
Spread a band of white gesso on your illustration board or watercolor paper. Tear rice or tissue paper into somewhat triangular pieces and place them on the gesso randomly, thinking of loose edges and varied surfaces. Leave some edges standing up. Below this area, spread a band of gel medium. Model the gel and leave it rough and textured. Let dry completely.

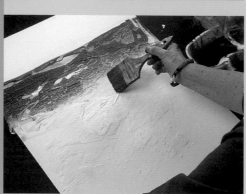

2: APPLY PAINTS
Float rich, thick acrylics over the dry paper surface in even passages to get a sedimentary effect as the paint settles into the crevices. I use cool, deep variations of purple. Let the paint skip over some areas to leave white flecks and/or valleys for interest.

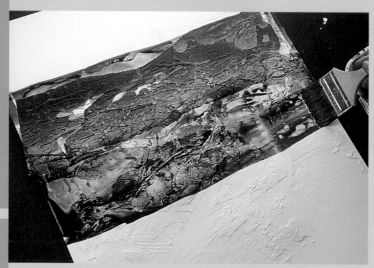

3: CHANGE COLORS
Change colors gradually as you work your way through the different strata of the design. Add yellow and blue watercolors to represent a tree line. Mix a rich purple watercolor to overlap the tree layer.

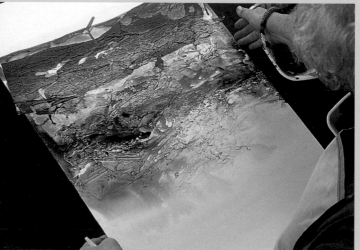

4: CREATE A GRADED WASH
Gradually add more and more water to the purple watercolor mix and grade it down the painting. Let the water allow the paint to bloom and move. Tilt the paper around to allow rock shapes and other organic shapes to emerge.

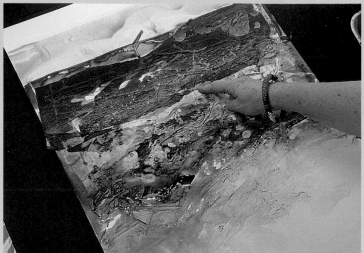

5: Determine the Next Steps

Take a look at your painting at this stage. Does it have any distracting white areas? If so, take these out with a little paint and water. Does it have enough texture? If not, try flecking a little flow enhancer as "rock" in the dark, lower purple areas. Have your painting reflect distance and atmosphere. Let all wet paint dry.

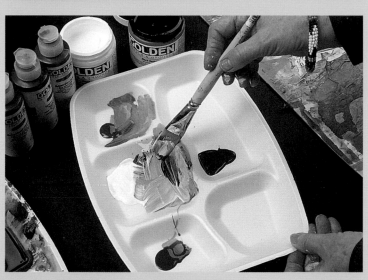

6: Mix Opaques

Mix acrylics with white and black gesso for a variety of opaques to use in the mountains and sky. By using a limited palette we ensure that the opaques and transparents will always harmonize.

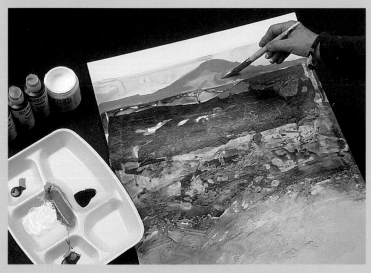

7: Paint the Mountain

Use your opaques to paint the mountains, bringing them down in a path that will lead the eye and changing values within the mountain to keep interest in that area.

8: Add Final Details

Use your opaques to get rid of any distracting colors or white spaces left in the painting. Pay attention to the color scheme in the area you're fixing: Let each layer of strata have its own separate color scheme. Every new opaque you add will spark the viewer's eye, leading it through the painting.

9: Paint the Sky

Paint a gray shade as the sky, using a shape that's the reverse of the mountains. Keep the sky and mountains at different values.

Work to finish the mountains and sky with tints and shades of acrylics, adding either white or black gesso to your colors respectively.

10: Add Unifying Touches

Use watered-down white gesso to float a mist into the top layers, representing mist in the mountains. Keep this layer a different width than the other layers of strata for variety.

SHOW THE WEATHER

Paintings come to life when you create the effects of weather: Fog suggests a pensive or somber mood. Sun and sharp shadows create a happy feeling. Rainy weather makes us want shelter.

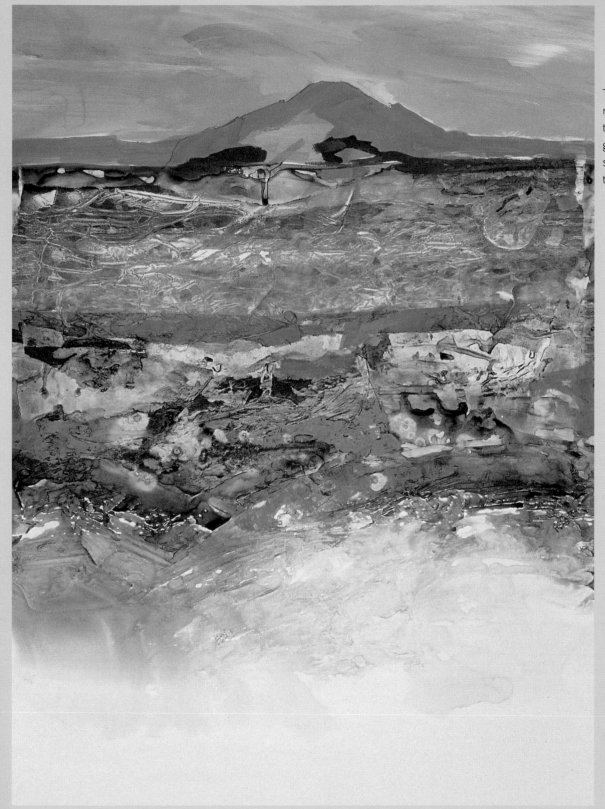

The finished painting moves from opaque at the top to transparent gradation at the bottom, showing change and transition.

creating a SEASCAPE

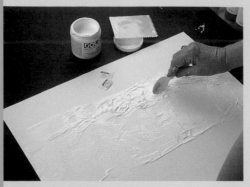

The vastness of the sea has always been an attraction for artists. We want to speak of its mystery and overpowering strength, its fluidity and constant change.

Using a wide, low format for this demonstration emphasizes the enormity of the sea. We can create shells, sand and sea creatures with surface texture. We can use water the way the sea does, letting it have its way as it moves through the painting.

1: PREPARE THE SURFACE

Spread a thick, wide band of white gesso across your board. Use a spoon, a pencil or the end of a paintbrush to model the gesso into shell shapes. Sprinkle salt into the gesso to create the look of sand: Don't glob on the salt—keep it thin. Let dry.

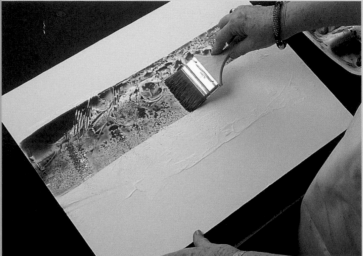

2: APPLY PAINT

Mix a warm, rich watercolor palette made up of organic colors. Float a warm paint mix over the textured surface. The sedimentary paint will settle into the texture and melt away the salt.

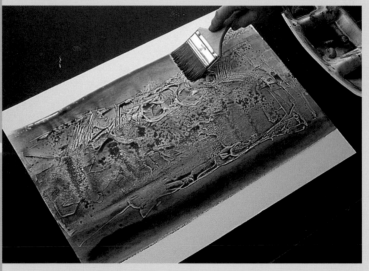

Remember not to go over areas you've already painted: Float each color mix on with one stroke.

MATERIALS LIST

Surface
Illustration board

Brushes
1-inch (25mm) flat acrylic
3-inch (76mm) flat bristle

Paints
Watercolors: Yellow Ochre, Burnt Sienna, Alizarin Crimson, Phthalo Blue
Fluid acrylics: Turquoise (Phthalo)

Other
White and black gesso
Salt (fine grained)
Spoon
Graphite and colored pencils
Flow enhancer

"Observing the natural world or seeking out new materials or new ways to apply them can get us going."

—Maxine Masterfield

3: ADD TEXTURE

Break up the expanse of color on the flat surface at the bottom of the painting by dropping in flow enhancer. You can draw with the flow enhancer, creating little beach critters and new textures.

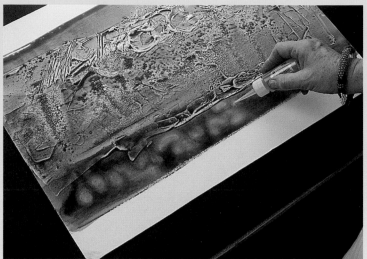

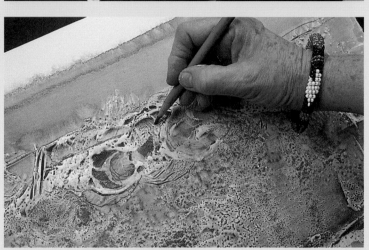

4: ADD CONTRASTS

When your paint has dried, go back into the painting with a graphite pencil, adding dark details to your shells here and there.

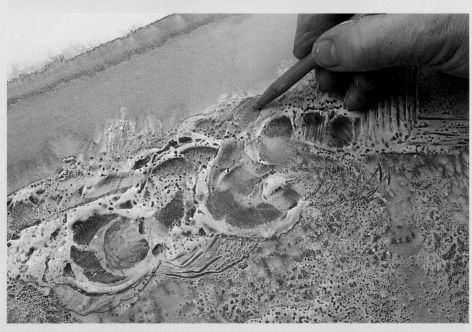

5: DETAIL WITH COLORED PENCILS

Use colored pencils to bring in more colors to your shells, coloring in areas that you'd like the eye to focus on. Enjoy the surface of the gesso as you work.

ADD A TOUCH OF REALISM

The contrast of graphite or colored pencil helps bring realistic images into an abstract work.

6: WORK ON CONTRASTS

Add black gesso to your blue acrylic paint, adding a little white gesso to help bring out the blue. Use this dark blue-gray as a sky color that will complement the orange sand.

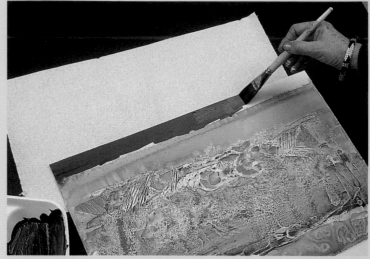

7: UNIFY COLORS

Carry the blue from step 6 down to the bottom of the painting to give the painting a base. Add more white to the mix to change values for variety.

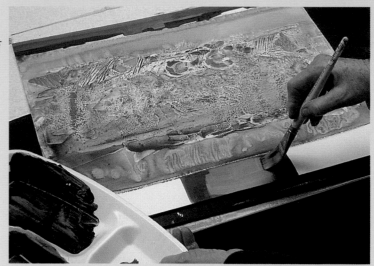

8: ADD FINAL DETAILS

When your paint has dried, use colored pencils to draw symbols, doodles or other graphics to bring interest and texture to the bottom of the painting.

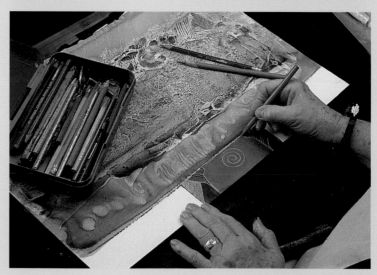

EXPAND ON REALITY

Create your own ocean out of your imagination. How would red waves look? What forms of sea life can you create that no one has ever seen?

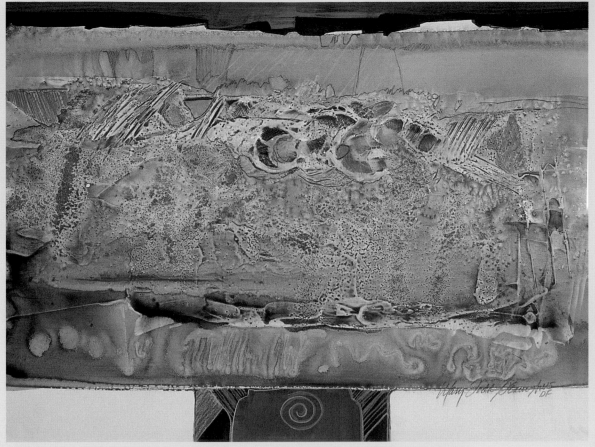

Final Seascape Painting
This painting signifies time and creation: the effects that sky, earth, water and time have on one another.

This vigorous seascape captures the essence and power of the ocean. Betts takes us to oceanic worlds, showing us more about the subject. He creates waves so sheer we see the algae. We see light in dancing droplets. Freedom and spirit hold hands.

NIGHT SHORE ＊ *Edward Betts* ＊ *24"×30" (61cm×76cm)* ＊ *Acrylic on watercolor board*

SUNSCAPE · *Mary Todd Beam* · *24"×63" (61cm×160cm)* · *Acrylic on foil* · *Collection of the artist*

"Creative ideas can be sparked by having a constant awareness of seeing situations and objects from an original, unconventional viewpoint."

—Guy Lipscomb

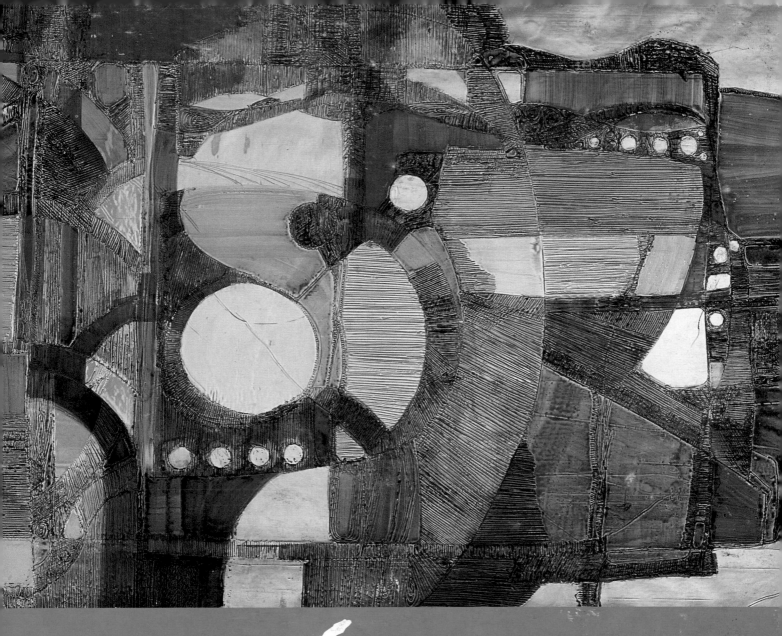

Man-made subjects can seem cold and

unyielding, without emotional stimuli,

but they have become an integral part of

our lives and their symbolism is intriguing

and challenging. We can use symbolism to say many things

about this world and our human responses to it. We may look

at rust or the wheels of a train as a way to suggest the

passage of time. We can get up close to technology and

use the diagrams of a circuit board to suggest communication. The

life force as expressed through machinery can be as strong as that expressed

through the powerful forces of nature.

6 Discovering Your Connection to the Man-Made

EXPRESSING YOUR WORLD

Where do you live? Can you capture the charm of its character? A house can be a cosmos or a world of its own. It can be a mirror of its inhabitants and can chronicle their lives.

Taking a Closer Look at Man-Made Objects

I could never understand how people could be interested in painting man-made things such as engines, trains and automobiles. That is, until I took my viewfinder to explore these things close-up. There it was: The designs were compelling, the textures were intriguing and I was hooked.

Working with man-made subjects brings out your ability to see abstract forms and shapes, as most man-made things are geometric in design and can help expand your understanding of design elements.

Searching for inspiring materials can be revealing and fun. Every new material brings on an onslaught of unclaimed possibilities. You may spend the rest of your life dealing with one of these possibilities, but until you find that one that opens up the floodgates of your gift, you must continue this search.

EXAGGERATE THE MAN-MADE

Age brings a subtle patina and a restful glow to man-made objects. The muted colors and textures seem to calm our eyes. They represent the passage of time and aging.

Try to be daring with inanimate objects. Use exaggeration of color or design more creatively with these subjects. Bring out more blue in the shadows or hint at an aura around certain areas. Flatten the plane or hint at metaphorical content.

*Watercolor on paper * Collection of Tom and Dena Gianas*

TIME MECHANISMS * Donald L. Dodrill * 19" × 29" (48cm × 74cm) *

Elements of antique clock parts combine with a group of modern dancers to signify the relation of the dancers' rhythmic movement to timing.

FAULTLINE (WALL SCULPTURE)

Deemer guides our eye over minute changes in line and surface with a close view that is unique and compelling. She shows us the constant aging process that goes on in the earth.

* Jean Deemer * 27" × 31" (70cm × 80cm) * Acrylic and collage on handmade paper

"If you are repeating yourself and desiring a new approach to your art, try doing something that you haven't done before. Explore some new territory."

—Mary Todd Beam

creating the
LOOK OF METAL

These demos will show you how to mimic the appearance of rust and the aging process of metal. Think of how you could do a large painting and feature this process.

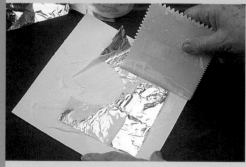

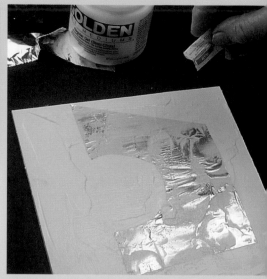

1: CREATE YOUR SURFACE
Use an adhesive spreader to spread gel thickly over the surface of your board. Imbed the foil in the gel and scrape a thin layer of gel over the foil to keep it secure. Sprinkle salt over the gel and let dry. The gel will dry clear.

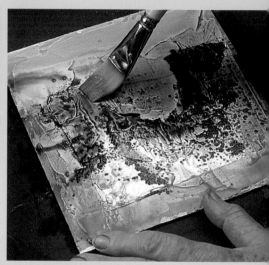

2: PAINT ON "RUSTED" METAL
Use some blue acrylic mixed with a little Quinacridone Crimson, keeping the paint real wet. This gives your metal a patina.
Add in some Quinacridone Gold as rust.

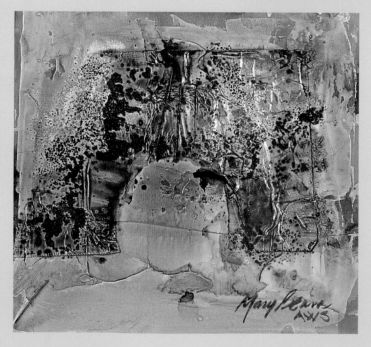

MATERIALS LIST

Surface
Illustration board

Brush
1-inch (25mm) flat acrylic

Paints
Fluid acrylics: Turquoise (Phthalo), Quinacridone Gold, Quinacridone Crimson

Other
Gesso
Gel
Salt
Sand
Aluminum foil
Adhesive spreader

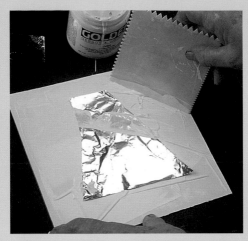

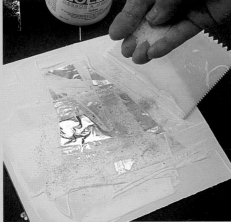

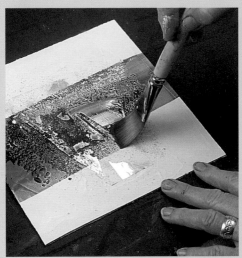

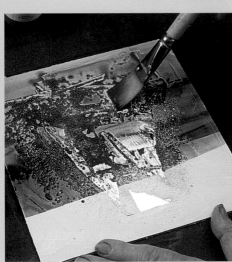

1: CREATE YOUR SURFACE

Use an adhesive spreader to spread gesso thickly over the surface of your board. Imbed the foil in the gesso and scrape a thin layer of gesso over the foil, leaving some places exposed. Sprinkle sand over the surface, shake off excess and let dry.

2: PAINT ON "RUSTED" METAL

Use some blue acrylic mixed with Quinacridone Crimson for a cool lavender, keeping the paint real wet. This gives your metal a patina.

Add in some Quinacridone Gold as rust, brushing it on lightly in some places and thicker in others for variety.

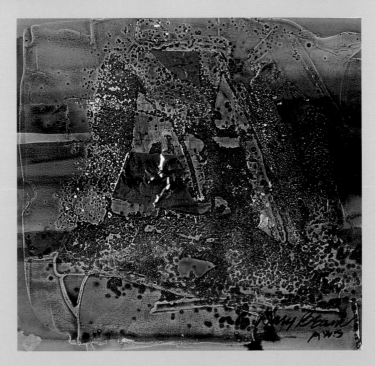

making FOIL PATTERNS

Let's go right to man-made and see what we can do with it by painting and embossing foil. You may want to use the results of this demonstration as a piece of a larger work: It's a neat way to create a really different surface in a collage.

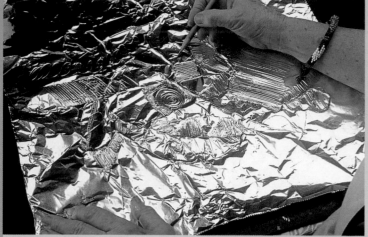

1: EMBOSS FOIL SURFACE

Crinkle your foil a little and place it on the foamcore shiny side up. Use your pencil to emboss designs, shapes, patterns, symbols, linework, crosshatches, pebble textures, etc., over the foil.

Continually turn the paper, changing the direction and size of your patterns for interest and variety. Watch as wonderful effects appear: Lines over wrinkles in the foil can resemble ripples over the water.

When you're finished patterning, wipe the foil surface with ammonia, using a soft rag, to remove the oils left by your fingers.

2: APPLY COLOR

Use a brush to apply your acrylics over the surface patterns, using enough water with your paint to keep it thin in places; let paint get thicker in other areas to get in the grooves of the surface. Try mixing colors right on the foil surface. Let dry.

MATERIALS LIST

Surface
Aluminum foil

Brush
1-inch (25mm) flat acrylic

Paints
Fluid acrylics: Turquoise (Phthalo), Quinacridone Gold, Quinacridone Crimson

Other
Foamcore
Pencil
Ammonia
Rags
Gesso

METAL ART

Are metal surfaces intriguing to you? We wear metal jewelry and use metal in all forms in our daily lives, so why not try it as a media? Why not view all materials as a source of art?

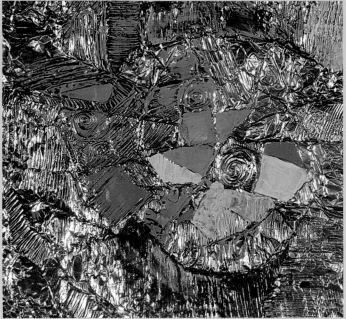

3: ADD OPAQUES

Paint in some flat areas for contrast, using opaques mixed from some gesso and your acrylics. Try drybrushing them on in places to really pick up the foil texture.

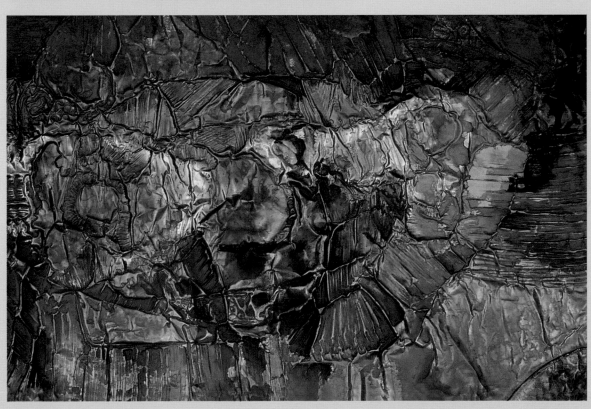

The embossing technique also works great on copper foil.

"The joy of painting is the exploration of who you are, how you see and feel and how you think in paint." —Carole D. Barnes

Do Buildings Talk?

You bet buildings talk! They say much about those who've dwelt there. They can be so important in describing our architectural heritage, our carpentry and engineering skills, and general cultural tastes. If you're sticking to a realistic tradition, you must render a building absolutely. The perspective, as well as its construction, must be accurate. Then, I think it's important to make the viewer feel the weather. This holds true for a realistic landscape as well: The weather can help set the mood of the painting.

This house had so many textures—the tin roof, rhythmic wires, bleached wood and triangular shadows. Transparent watercolor was the perfect medium to bring out this texture and to create the lovely shadows.

CAT ON A HOT TIN ROOF

* *Mary Todd Beam* * *30"×40" (76cm×102cm)* * *Watercolor on illustration board* * *Private collection*

WHICH ROOM IS YOUR FAVORITE?

Rooms can have a symbolic value. People who nourish like the kitchen. Historians like the attic. Outgoing social people like the living room or a gathering place. I hope you like the studio. Matisse loved his studio so much he did a painting of it all red and featured everything in it as special.

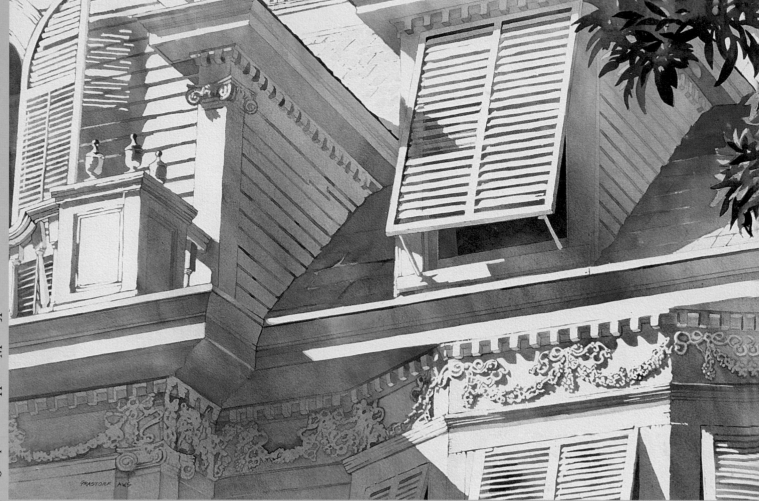

* *30"×40" (76cm×102cm)* * *Watercolor on paper* * *Private collection*

Grastorf narrows her subject to an almost abstract design of triangles, squares and line, and then renders the subject with skill and patience.

"To me, creativity is a reaching down into what's me and working from a resource of personal experience and growth." —Jean Grastorf

GATHER THE PIECES

Assemble a still life from your favorite room. Be sure it contains all kinds of different textures. After you've made your choices, think about any symbolic content in the items you've chosen. Can you find meaning in this adventure? View the still life as a metaphor for your life and place items in it that are meaningful to you.

constructing a STREET MAP

Draw a map of directions on how to get to one of your favorite spots in your town. But it must be a pictorial map, just signs and milestones or architectural features. Record the interesting things you notice along the way. Flatten or symbolize the hills, turns and buildings. I've shown you how to get to my favorite spot for breakfast (see *Top of the Morning*, facing page).

Your map can be a symbol of your creative path through life.

1: CREATE UNDERPAINTING AND DRAWING
Use a 3-inch (76mm) bristle or foam brush to create a wet-in-wet underpainting, dropping in colors and splattering paint to show variety, lifting out other areas to create layers and resemble roads. Let dry.

Go back in with a ruler and a pencil and construct your city, keeping shapes geometrical and straight.

2: PAINT THE BUILDINGS
Use watercolors and a flat brush to fill in your buildings. Alizarin Crimson mixed with some Burnt Sienna and Phthalo Blue works well as a brick color.

Use Phthalo Blue to paint the windows. Wash out one side of the building to represent clouds crossing over, movement and/or changing time.

MATERIALS LIST

Surface
Illustration board or watercolor paper

Brushes
Foam brush
3-inch (76mm) flat bristle
½-inch (12mm) flat

Paints
Watercolors: Alizarin Crimson, Burnt Sienna, Yellow Ochre, Phthalo Blue

Other
Ruler
Graphite and colored pencils
White or black gesso

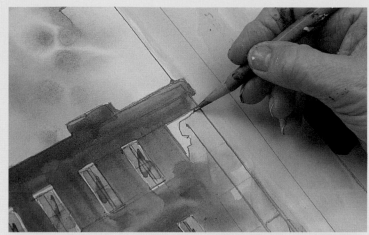

3: Add Details

Develop your pencil lines, threading them through the painting to connect one space to the next. Use your lines and other details to guide the viewer through your "map."

Use cool gray opaques to create roads by mixing white or black gesso with your paints. When they dry, try your colored pencils to add road details and signs that will lead the viewer.

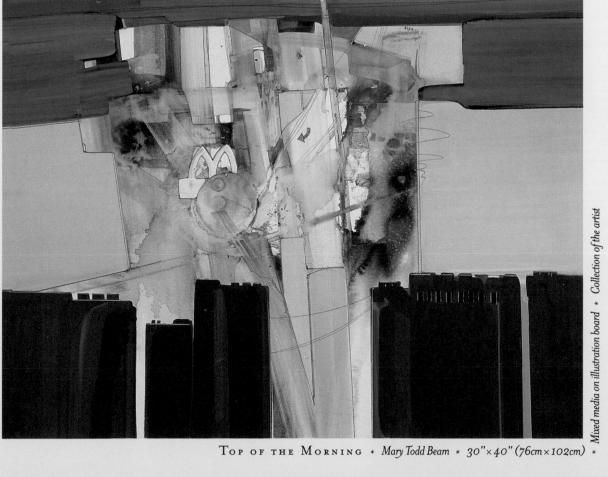

Top of the Morning ∗ *Mary Todd Beam* ∗ *30"×40" (76cm×102cm)* ∗

Mixed media on illustration board ∗ *Collection of the artist*

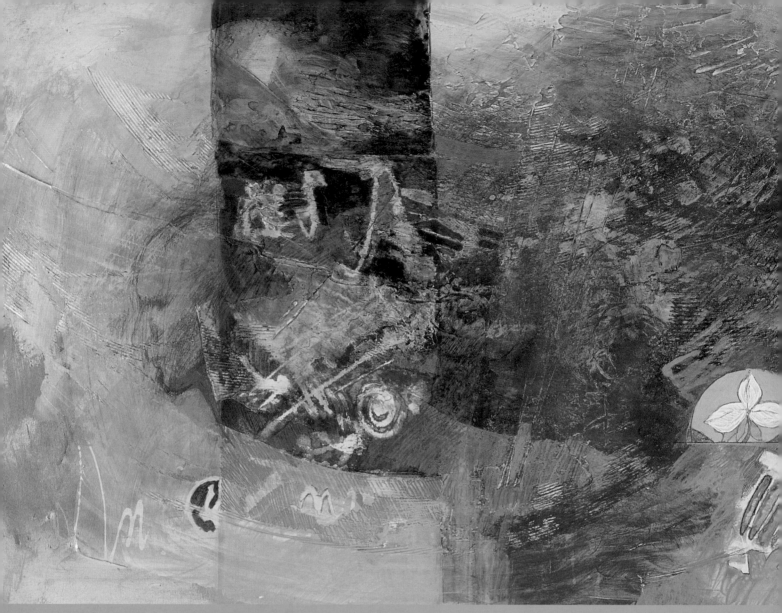

An Inward Look * Mary Todd Beam * 28"×60" (71cm×152cm) * Mixed media on gel * Collection of the artist

"In order for my work to continue to evolve, I become involved in playfulness and take the opportunity to look at the 'what-ifs.'

Whatever the result, it expands my vision by letting go of who I think I am and discovering the spirit within." —Jean Deemer

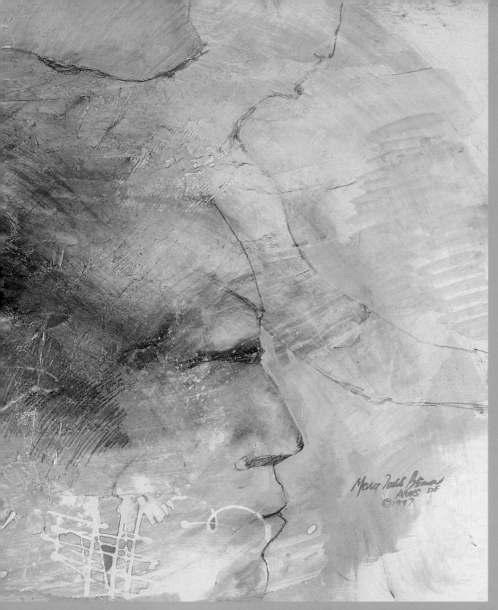

7 Celebrating the Power of Play

There is much magic involved in painting. Without that magic the painting can become a mere illustration. Magic happens when the artist decides to let his imagination rule—or at least play a role in what he is doing. He is not afraid to pepper the painting with a touch of fantasy. Children have this gift, and we can become like them with a bit of effort. So get a childlike mind-set and make some magic.

HAVE WE LOST IT?

What happened to painting freely like a child? To get that freedom back, let go of all precon-ceived ideas about the outcome of your work. Use your body movements to transfer energy to paper. Enjoy the process and materials!

Playing With Figure Shapes

Think of how you would paint if you were a child. Pretend no one will ever see this painting but you. Wow, does complete freedom in painting feel good?! Take some of that feeling into your next painting. I think it's addictive.

Think back to those childhood days. We were able to express ourselves when we were small. We would make a stickman. We can find that simplicity again.

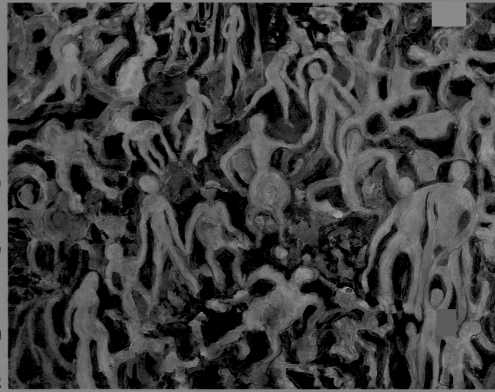

BETWEEN PLACES AND TIMES #1

* Marie Dolmas Lekorenos * 21"×29" (55cm×74cm) * Acrylic and gesso on paper * Collection of the artist

These artists have fun with figures in motion. Each shape or figure leads to another as they move across the paper.

DANCE—ECNAD * Trish Arnold * 32"×40" (81cm×102cm) *

Mixed media * Collection of Karen Betow

"I've never enjoyed painting more than I do today! It's the only place you can find the 'real me,' and I'm grateful for that outlet."
—Toni M. Elkins

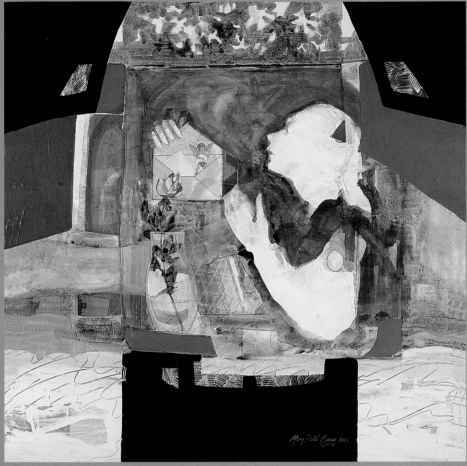

Figure shapes can be made by working freely with a dark, such as black gesso, or by cutting or sculpting the figure from the white of the paper or paint. Stay loose. Use a pencil to create guidelines if you need help locating the parts of the figure that will be most expressive.

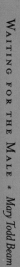

WAITING FOR THE MALE * *May Todd Beam*
* 42" × 42" (107cm × 107cm) * *Mixed media on illustration board* * *Collection of the artist*

After years of holding back, Brunsvold found herself and her style in these magical animals. Her use of strong color makes them even more playful and fanciful.

Collection of Resurrection Hospital, Chicago, IL

JURASSIC * *Chica Brunsvold* * 22" × 30" (56cm × 76cm) * *Acrylic on paper* *

99

loosen up with
GESSO *and* NEGATIVE PAINTING

*L*et's try this game: Add gesso to your surface to keep the paint from being so controlled, giving magic a chance to happen. Use negative painting. Each stroke may reveal some casual suggestion of a figure or animal.

Put on some music: I suggest Barry White (and that's not a color) to add inspiration and rhythm. The surface of the painting will break up, and there's no way you can plan what is happening. It will help you and break up the washes into new images if you'll give it a chance.

MATERIALS LIST

Surface
Illustration board or paper of your choice

Brushes
3-inch (76mm) flat bristle
½-inch (12mm) flat acrylic

Paints
Watercolors: Alizarin Crimson, Burnt Sienna, Yellow Ochre, Phthalo Blue

Other
White gesso
Soft drawing pencil
Plastic wrap
Adhesive spreader

SMOOTH GESSOED SURFACE

1: PREPARE THE SURFACE AND SKETCH A ROUGH FIGURE
Paint white gesso onto your surface, leaving it a little rough. Let dry.
Draw in a figure using gesture and outline. Think of action figures such as football players or runners.

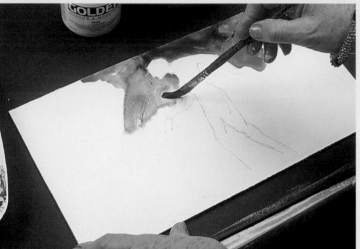

2: START PAINTING
Start painting around your figure, using enough water to keep the color wet and moving, varying color and value as you go.

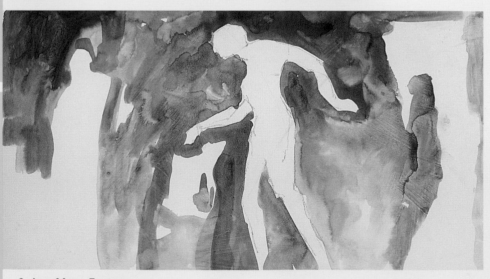

3: ADD MORE FIGURES
Continue painting, looking for new places for figures to develop. Use negative shape painting, watching both sides of the brush for ideas.

ROUGH GESSOED SURFACE

1: PREPARE THE SURFACE
Use a brush or an adhesive spreader to lay a thick coat of white gesso onto your surface.

Lay plastic on the gessoed board, pressing it down to make shapes in the gesso. Let dry.

2: LET GO AND PAINT
Once the gesso is dry, remove the plastic. Start on the right with your watercolors, developing negative-shape fantasy figures. As you work across your painting surface, hunt for figures. Relax and don't try too hard. Talk to someone or listen to the radio to babysit the literal side of the brain.

Add in darks to change your values and bring out contrast in new figures.

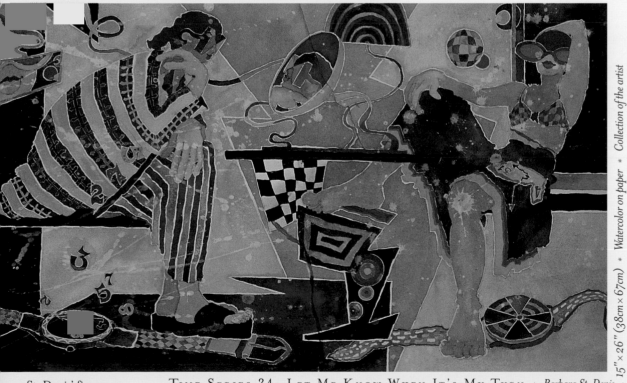

St. Denis' figures are playful and amusing, coaxing us to form a story around them in our minds.

TIME SERIES 34: LET ME KNOW WHEN IT'S MY TURN * *Barbara St. Denis* *

15" × 26" (38cm × 67cm) * *Watercolor on paper* * *Collection of the artist*

printing with
PLASTIC

Can you remember how to fold newspaper and cut paper dolls or trees like you did when you were little? Try it again. Or use any wonderful shape that you cut from plastic.

Try working with the heavier plastic you buy in the hardware store. Different weights of plastic make different prints, so experiment with several different weights—from garbage bags to Plexiglas.

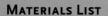

MATERIALS LIST

Surface
Illustration board or paper of your
 choice

Brush
3-inch (76mm) flat bristle

Paints
Fluid acrylics: Turquoise (Phthalo),
 Quinacridone Crimson,
 Quinacridone Gold

Other
Light-weight plastic
Scissors
Soupy white gesso
Black gesso

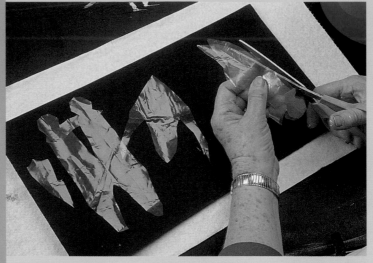

1: PREPARE THE SURFACE AND THE PLASTIC SHAPES
Cover your board or paper with black gesso. (If you don't want to use gesso, you can use any dark color. Try mixing a dark color from your acrylics.) Let dry.

While your surface dries, cut out figures or shapes from your plastic. Save both the positive and negative shapes.

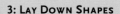

2: COVER THE SURFACE WITH A LIGHT LAYER OF PAINT
Mix your white gesso with water to a soupy consistency and cover your painting surface.

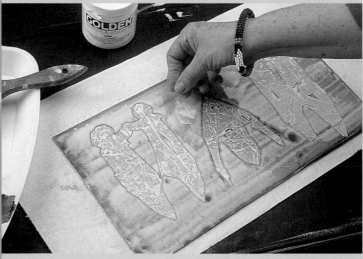

3: LAY DOWN SHAPES
Lay down your plastic shapes in the wet gesso. Allow it to dry.

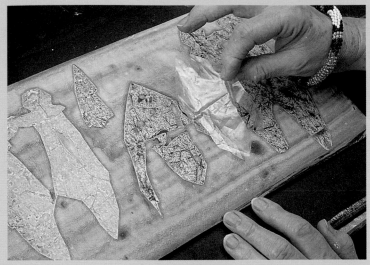

4: REMOVE SHAPES
When the gesso is dry, peel back the plastic to reveal the imprinted shapes.

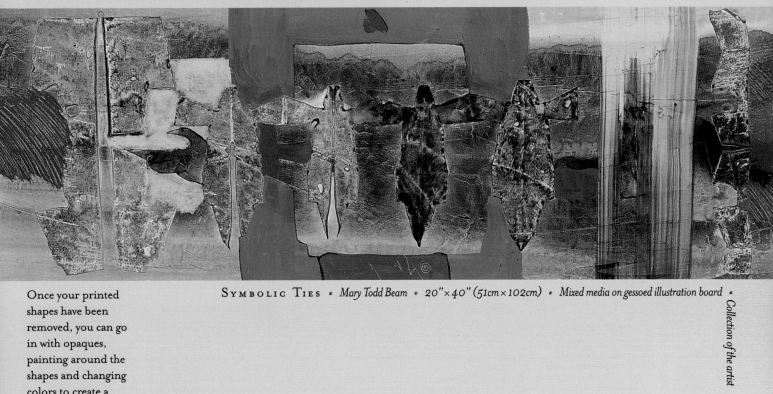

Once your printed shapes have been removed, you can go in with opaques, painting around the shapes and changing colors to create a pleasing design.

SYMBOLIC TIES * *Mary Todd Beam* * *20"×40" (51cm×102cm)* * *Mixed media on gessoed illustration board* *

Collection of the artist

"There would be no universe without creativity and in my little world, it's a must."

—Juanita Williams

tricking your SENSES

Children instinctively know how to divide paper in an interesting way. Look at your last few paintings. How did you relate to the horizon? Did you divide the paper in the same way each time? Were you afraid to risk a new format? (See chapter 4 for design instruction.) Are you repeating yourself in each painting? You can trick yourself into discovery by using untapped sources that are undeveloped.

"Close your eyes and make believe, hear a voice and put color to it. Describe someone's touch with brush and paint."

—Sally Emslie

MATERIALS LIST

Surface
Illustration board or paper of your choice

Brushes
2-inch (51mm) flat acrylic
3-inch (76mm) flat bristle

Paints
Fluid acrylics: Turquoise (Phthalo), Quinacridone Crimson, Quinacridone Gold
Iridescents: Iridescent Bronze

Other
Canning wax (from the grocery store)
Crayons
Black and white gesso
Single-edge razor blade in holder

1: ADD WAX AND CRAYON

Wax the edges of your board or paper. Then use the wax to draw over the surface, pressing down hard. You won't be able to see what you're drawing, so let go and have fun.

Pick up your crayons and draw anything that feels good without getting too literal.

Try putting the wax and crayons in your nondominant hand to further trick your senses.

Keep your scribbles simple, but work to get as much color on the surface as you can. This layer will be your underpainting.

2: COVER UP YOUR COLOR

Dip your brush in water and squeeze out the excess liquid. Use this wet brush to paint black gesso over your colored surface. The crayon and wax may show through, as they can "resist" paint, but it's OK if it is completely covered.

Leave an area uncovered here and there for added interest. Let dry.

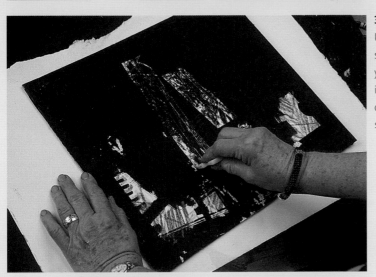

3: BRING BACK THE COLOR

Use your razor blade to scrape off the black gesso, scraping out shapes and patterns. Continually turn your painting as you scrape to see what is happening all over, but don't be thinking too much about design. Just try to connect shapes and enjoy the surface.

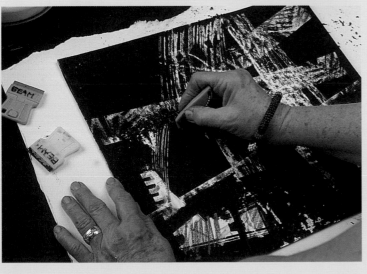

Vary your scraping, using the flat edge or point of your blade to make thick or thin lines. Notice how the wax has left softer resisted areas, while the crayon creates hard lines.

LET YOURSELF GO

Don't be afraid to create some chaos. Go ahead, be five years old again!

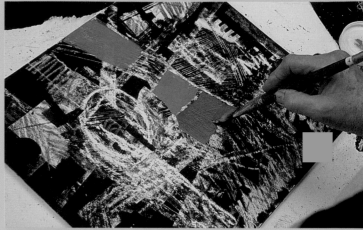

4: DEVELOP WITH OPAQUES

Mix neutral opaques with your acrylics and either black or white gesso. Use the painting-around technique (see page 14) to find your subject and bring it out. Be careful not to go too far: You don't want to cover up anything you'd like to keep.

Join shapes and values, changing shapes by changing the value. Think of patterning and design techniques that will help lead the eye around the painting. Let dry.

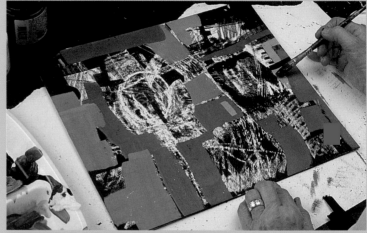

5: TIE IT ALL TOGETHER

Once you're finished opaquing, try bronzing all or part of your work to unify the design, going back in with your opaques if necessary.

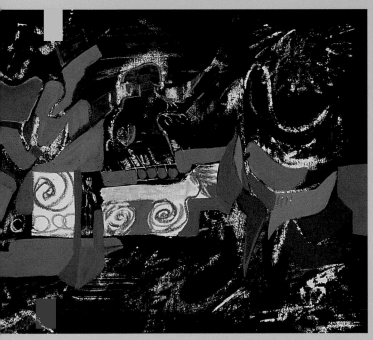

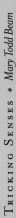

Tricking Senses * *Jennifer Lepore Kardux*

Student at work creating an underpainting.

" We are all taught to nurture our bodies, our spirit and our minds, but little instruction is given to protecting and allowing the seed of creativity to grow. " —Trish Arnold

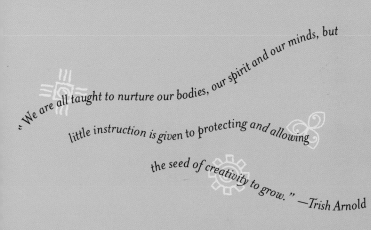

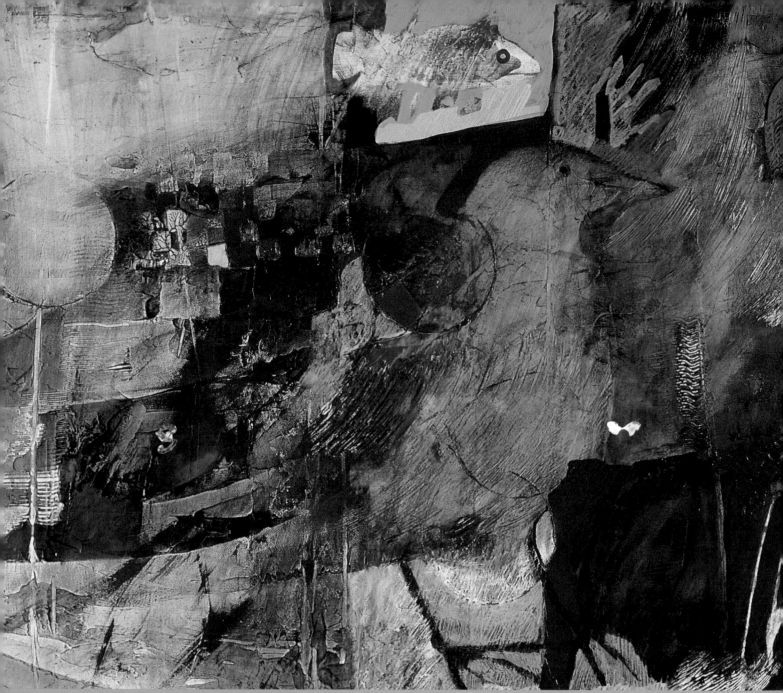

A Song Remembered (detail) * Mary Todd Beam * 24"×46" (61cm×117cm) * Acrylic on canvas * Collection of Dan and Kathy Beam

"Creativity is the ability to produce a unique or uncommon idea that comes from within ourselves that is influenced by a lifetime of experience." —Carrie Burns Brown

Symbols have been a part of our lives since the beginning of mankind. They were a means of communication before our modern language, and much of our alphabet was derived from them. These traditional symbols hold an elemental power that transcends words: They are not merely decorative patterns, they are the building blocks of all aspects of creation. Many modern artists are interested in using symbols to bring a spiritual influence into their work, and they can make use of them in several meaningful ways.

Creating *8 Your Personal Symbols*

FIND MEANING

A color, a repeated mark or an interesting shape—these could all be symbols with unspecified meaning. By thinking about your life, likes and repeated images can bring meaning to your work.

Keeping a Symbol Diary

DOODLING FOR SYMBOLS

Practice doodles while talking on the phone. When you keep the left side of your brain occupied with talking, the other side may give you some good designs. I do this as an exercise, and sometimes the doodles are better than a painting. They may be expanded into your work, or you can use just one particular element.

As you notice repeated shapes or markings in your work, keep a record of them. Put them onto a chart you can hang in your studio to be reminded of as you work. Add to it as new symbols pop up. These symbols should be meaningful, unique expressions of who you are, not just a symbol you've randomly selected.

My chart of symbols appears on this page. I incorporate these symbols in my work through drawing, stamping, incising into gel or imprinting.

Symbolic Subjects
Other common symbols include windows, vessels, apples or other fruit, birds, shells, doors, moon/sun, stars, fish, stairs and houses.

These artists incorporate symbols in their expressive work. These paintings appeal to us on several levels. We can enjoy the patterning, shapes and color, and then devise a story around the content they suggest.

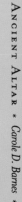

TIME PRINT * Juanita Williams * 40" × 30" (102cm × 76cm)

* Mixed watermedia on handmade paper * Collection of the artist

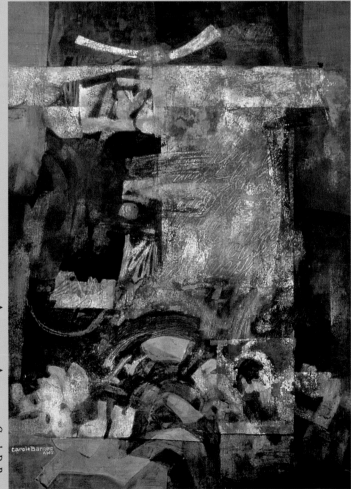

ANCIENT ALTAR * Carole D. Barnes

* 30" × 22" (76cm × 56cm) * Acrylic on paper * Collection of the artist

Holding Hands With Nature

Nature is consistent in her patterns. You can borrow her symbols and uncover the meaning of the forces she uses. These patterns also dwell in the human imagination, as you can see in contemporary art, and illustrate the likeness between nature and human art. Imitating these symbols can bring imaginative modes and rhythmic and dynamic elements into your work. Notice how certain symbols pervade all of nature and repeat themselves in all of creation.

Branching is one symbol that is used in trees as well as in lightning, etc. The spiral is one of my favorites and you will see it everywhere if you look for it. Others available to the artist are rosettes, parallels, repetitions, circles, and so on.

BOOKS ON SYMBOLS

DICTIONARY OF SYMBOLS: AN ILLUSTRATED GUIDE TO TRADITIONAL IMAGES, ICONS AND EMBLEMS. Jack Tresidder. Chronicle Books, San Francisco, 1998.

THE STONES OF TIME: CALENDARS, SUNDIALS AND STONE CHAMBERS OF ANCIENT IRELAND. Martin Brennan. Inner Tradition International, St. Rochester, Vermont, 1994.

IMAGES OF POWER: UNDERSTANDING SAN ROCK ART. David Lewis Willams and Thomas Dowson. Southern Book Publisher, England, 1989.

A FIELD GUIDE TO ROCK ART SYMBOLS OF THE GREATER SOUTHWEST. Alex Patterson. Johnson Printing Co., Boulder, Colorado, 1992.

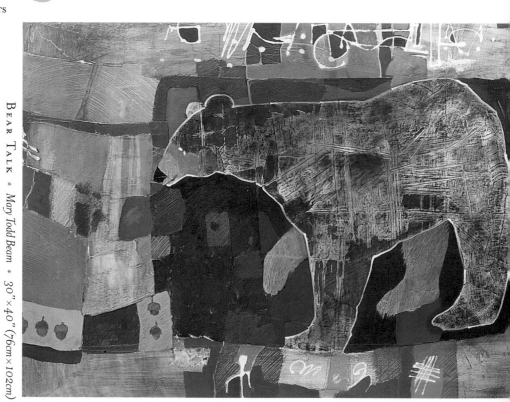

BEAR TALK * *Mary Todd Beam* * *30"×40" (76cm×102cm)*

* *Mixed media on illustration board* * *Collection of the artist*

I saw a television program on bears and was amazed at the way they talk to each other while they are small. I gave them an imaginary language here, and added acorns and a few trout to show how they are always so hungry.

Exploring Ancient Cultures

All ancient cultures had to resort to symbols of some kind to communicate before written language was available. We can study their symbols and decide if they are meaningful to us.

Skinner uses abstract archaic marks to suggest an ancient culture. She has lived in the western United States much of her life and has had the opportunity to see pictographs and petroglyphs, and carries this knowledge into her work. Metallic paints suggest the preciousness of the culture.

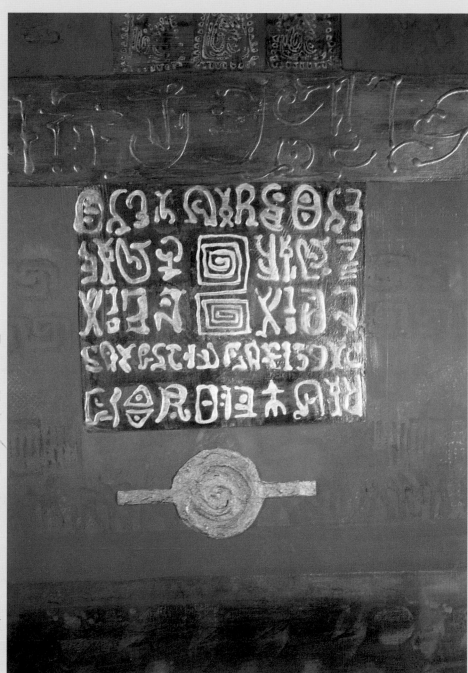

TEMPLE MARKINGS V * *Delda Skinner* * *30" × 22" (76cm × 56cm)*

* *Acrylic, casein, collage* * *Collection of the artist*

Finding Your Own Symbols

It's exciting to see that artists are developing their own symbols. Shapes can become symbols. Color and texture may become symbolic to the artist. Repetitive marks may also be symbols.

After working with symbols, you'll find that some are more appealing to you than others. Always go with your passion and choose the things that are most meaningful to you. Viewers may miss the meaning, but they'll never miss seeing the passion. Sometimes you may face a situation where you think your feelings are too strong or too intimate to express. Then symbolize them to make them seem more palatable to the public.

*Watercolor and mixed media * Collection of the artist*

PATTERNS & PAINT * *Cheryl Curnick* * 35"×39" (90cm×100cm) *

Experience and intuition have led this artist to find her personal symbols. Curnick explores her rich culture and does it in a narrative style, as a "visual tapestry of interwoven thoughts of fantasy and realism."

Torn paper, paint and collage papers develop a vibrant arrangement of texture and shape.

SYNCOPATION * *Carrie Burns Brown* * *13" × 13" (33cm × 33cm)* * *Watermedia and collage* * *Collection of Sherry Silvers*

SYMBOLIC STORIES

Can you remember a favorite fairy tale from your past? Fairy tales are a repository for cultural or ethnic wisdom. Are there symbols embodied in the story that have meaning to you? I always enjoyed the tales of Hans Christian Anderson. He used many symbols: water, tin soldiers, fish, coins, mermaids—the list goes on.

Try to "write" several fairy tales using only symbols, no words.

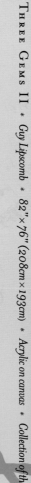

Lipscomb has developed symbols from years of introspective painting, never self-conscious but always expressive of his heart and mind.

THREE GEMS II * *Guy Lipscomb* * *82" × 76" (208cm × 193cm)* * *Acrylic on canvas* * *Collection of the artist*

MAKING SYMBOLS
with flow enhancer

Symbols can become an exciting part of your painting. They need to be related to a primitive type of technique, using strokes like those primitive man would have had available to him. These marks can be endowed with strength and energy, much like strokes Picasso made with his brush drawings.

Flow enhancer creates symbols with an organic, primitive feel. Edges will be rough or may bleed. (See page 11 for more on flow enhancers and related safety tips on using such products.)

EXPRESS YOURSELF

Use this technique to express your own "language." Let this language enhance sections of your painting or use it as a border. Incorporate it into your work to add interest, direct the eye, send a message or tell a story.

MATERIALS LIST

Surface
Illustration board, watercolor paper or canvas

Brush
1-inch (25mm) flat acrylic

Paints
Fluid acrylics: Turquoise (Phthalo), Quinacridone Crimson, Quinacridone Gold

Other
Gel medium
Adhesive spreader
Flow enhancer
Paper towels

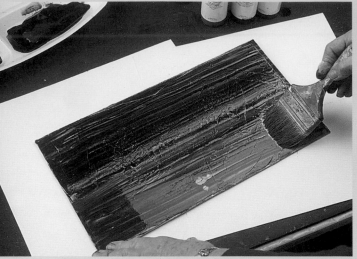

1: PREPARE THE SURFACE
Spread gel over your painting surface with an adhesive spreader, creating a smooth texture. Let dry. Apply a thick coat of dark acrylics.

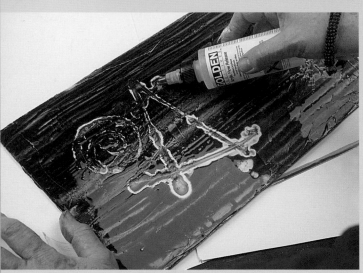

2: "DRAW" IN SYMBOLS
Draw symbols into your wet paint with flow enhancer. Let dry.

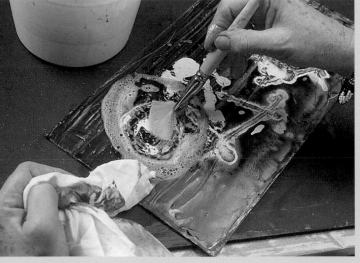

3: CLEAN UP SURFACE
Use a wet brush to scrub out areas of flow enhancer. Don't worry, the paint will stay put because these acrylics are staining. As you scrub, mop up with a paper towel. The texture and color of shiny bone will be left behind.

These symbols are drawn into wet paint with flow enhancer.

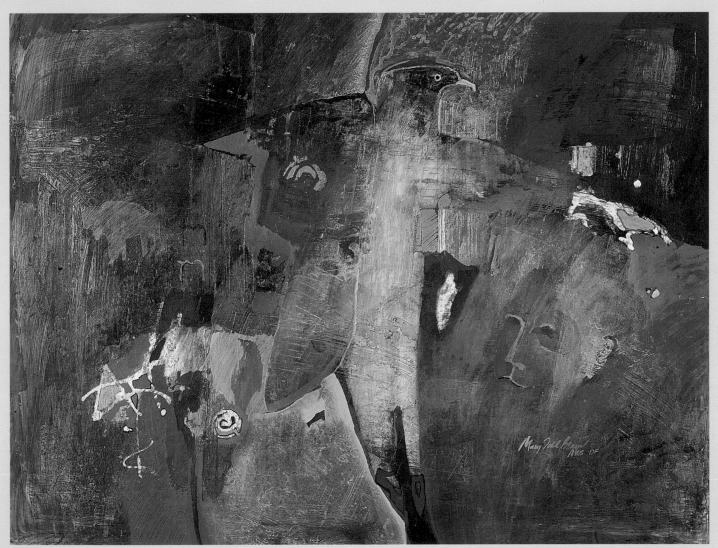

WHEN ANGELS DREAM * *Mary Todd Beam* * *30"×40" (76cm×102cm)* * *Acrylics on gel-textured illustration board* * *Collection of the artist*

117

scratching out SYMBOLS

Ancient man used rocks to scratch out designs on cave walls (petroglyphs). We can scratch on paper, varying pressure and producing a textural quality enjoyable to the viewer. We can scratch into a painting to expose underlying color, to make a new color or to bring unity to a color scheme.

1: PREPARE THE SURFACE
Coat your board with black gesso or any other dark color and let dry.

Mix white gesso with your acrylics to get a light color and paint it across your board with a large flat brush.

2: SCRATCH IN SYMBOLS
Use any scratching tools you can find to draw into the wet paint.

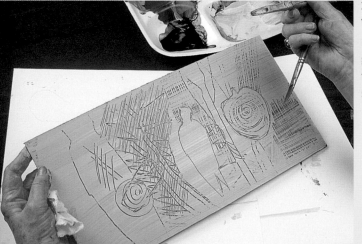

3: MOVE QUICKLY
Work fast before the paint dries. As the paint gets drier, the paint on the surface will not scratch away as easily.

MATERIALS LIST

Surface
Illustration board

Brush
3-inch (76mm) flat bristle

Paints
Fluid acrylics: Turquoise (Phthalo), Quinacridone Crimson, Quinacridone Gold

Other
White gesso or any light-colored paint
Black gesso
Scratching tools: end of a paintbrush, stick, razor, etc.

"Sometimes you have to simply destroy something to pull the painting around and get down to bones."
— *Carole D. Barnes*

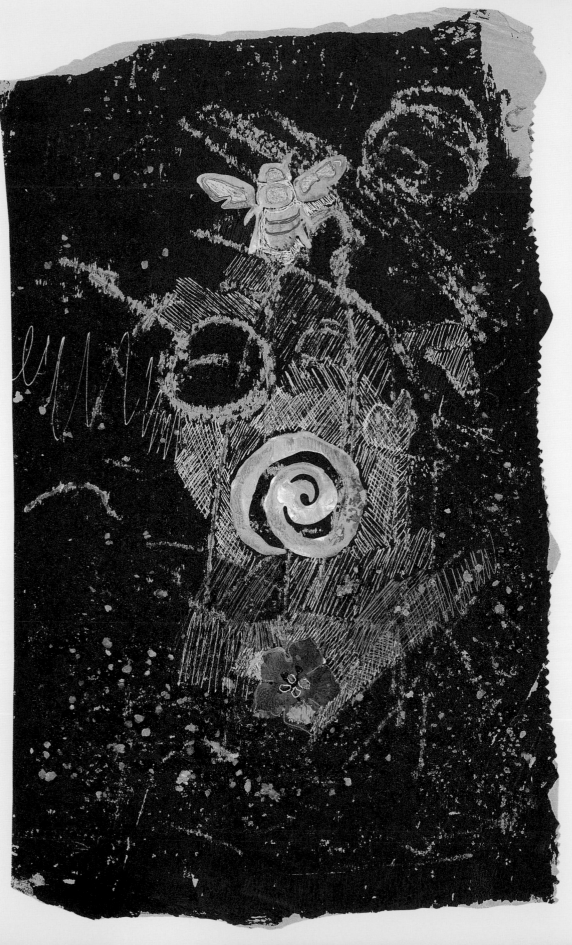

At my home, if something stays still long enough it will become an object or media for paint. If you use a nonprecious scrap of paper or revive a painting that has gone by the way, it releases your creative flow. Expectations of outcome are gone.

Find old paper, a paper sack, newsprint or cardboard (à la Rauschenberg) and see what happens. Try scratching or stamping, or try painting without a brush.

By now you have discovered ways to be more painterly, to change the surface you are working on, to work with a variety of materials, to create your personal palette and to attach meaning to whatever you do. Now, let's make our mark and walk the path. I will introduce you to others who can be models for us and who have pushed their talents to new heights. The medium doesn't matter. Maybe your personality is more suited for another medium. You won't know unless you try it.

Walking the Creative Path

Many artists now are starting in watermedia and working toward other forms of expression. Quilters are painting with the textures of their fabrics. Using predyed or preprinted fabrics, they form new patterns and make new art. In every field of art we see growth. We see those who experiment and take us to new levels of wonder and understanding.

WHY LIMIT YOURSELF?

Visit a museum that features contemporary art and see what you are drawn to the most. Think of how you can expand your work and give yourself room to grow.

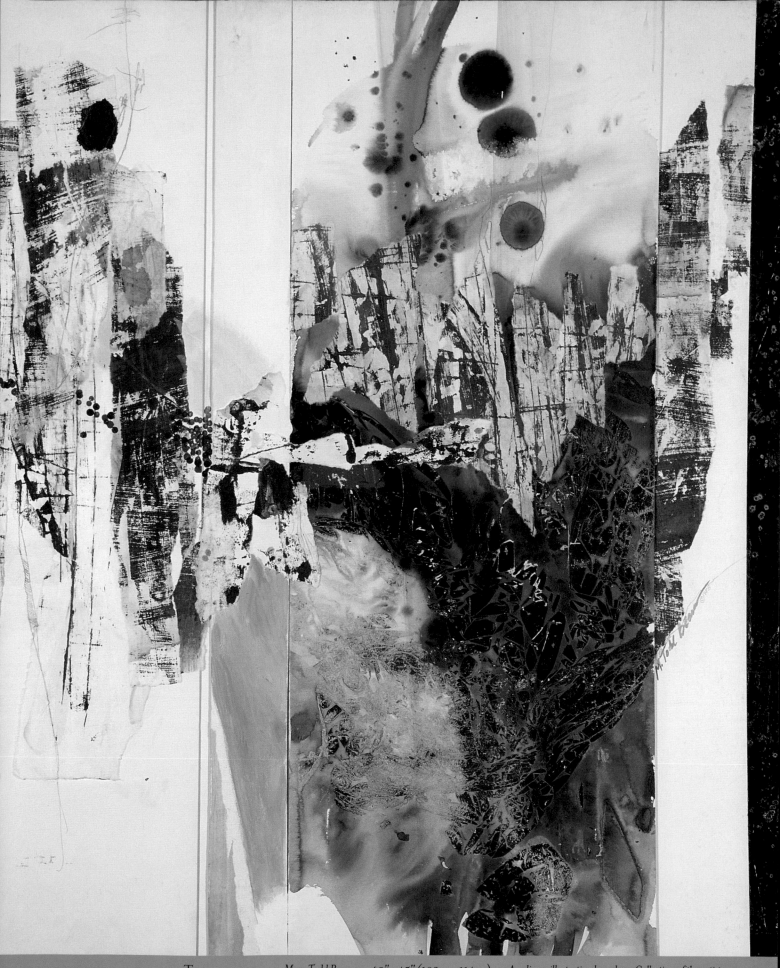

THORNBIRDS ∗ *Mary Todd Beam* ∗ *40"×45" (102cm×114cm)* ∗ *Acrylic on illustration board* ∗ *Collection of the artist*

constructing a NEW PIECE OF ART *from* OLD WORK

Gather your old paintings into a stack on the floor. Some may have not spoken to you for a while. Look at the colors and the patterns that run through each of them, both individually and as a group.

In this demonstration we will create a whole new dialog with the viewer by reworking and recomposing pieces of these paintings into a new work of art.

1: GATHER SUPPLIES
Gather your scrap work and any pieces of foil or other interesting surfaces you may have lying around. Start thinking about which scrap pieces might work well together.

2: MAKE SHAPES
Draw abstract shapes on the backs of your scrap paintings, varying the sizes and angles. Don't peek at the other side—these shapes need to be random.

Use a marker to outline the shapes you want, and then cut them out with your knife.

3: PUT SHAPES TOGETHER
Use white glue or gel medium to glue shapes together. Think of direction, and have a central focus and a base piece. Watch to be sure that the random patterns don't take your eye out of the "picture." Leave spaces between shapes. Carry your design out in space. No straight edges! When you finish putting the shapes together, you can go back and add paint as needed.

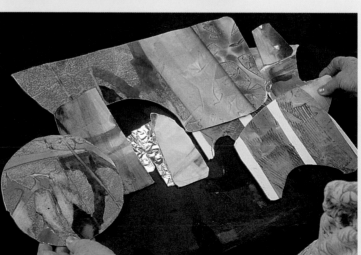

4: FINISH THE PIECE
The rhythm of the curved lines, the sparkle of foil and the patterning of light bring the eye into the painting.

Glue it all down to a canvas board or a piece of illustration board.

MATERIALS LIST

Surface
Canvas board or illustration board

Brushes
Medium-sized flat acrylic: as needed

Paints
Fluid acrylics: as needed

Other
Straightedge
Knife
Foil
Scrap paintings
Pencil
Marker
Gel medium or white glue

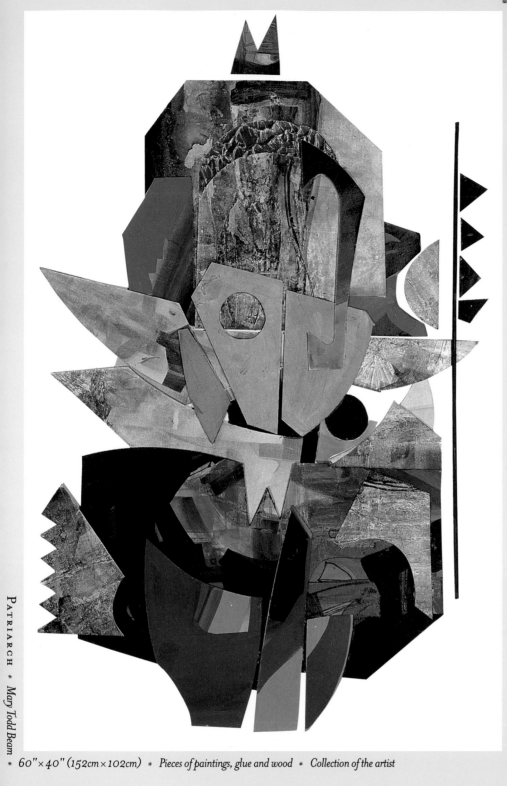

PATRIARCH * *Mary Todd Beam*

* 60"×40" (152cm×102cm) * *Pieces of paintings, glue and wood* * *Collection of the artist*

I started this construction by drawing out random shapes on the back of old paintings so I couldn't pre-order them by color or pattern and kill the spontaneity of the piece.

It's also fun to try arranging shapes by color or pattern. As one of today's popular photographers does, you can cut paintings into squares and sort them by color, then put the pieces together to make an image that appears real.

folding an old painting
INTO A NEW
PIECE OF ART

Here's another use for old paintings. We will coat the paintings to make them pliable, like leather, then fold them into freestanding "sculptures" or "appendages." This demonstration brings your paintings off the wall and out of the frame. When we push ourselves to reach for new images and new forms of expression that are challenging and expansive, we may hit on a stronger way to present our ideas.

MATERIALS LIST

Surface
140-lb. (300gsm) watercolor paper

Brushes
1-inch (25mm) flat acrylic
3-inch (76mm) flat bristle

Paints
Fluid acrylics: Turquoise (Phthalo),
 Quinacridone Crimson,
 Quinacridone Gold

Other
Gel medium
Leather thong
Natural found objects: beads, shells,
 feathers, raffia, sturdy sticks
Thread
Stamps
Hole punch

1: PREPARE YOUR SURFACE
Use a 3-inch (76mm) bristle brush to coat your watercolor paper with water and then a thin coat of gel. Go all the way to the edges.
 The gel will soften the paper, making it pliable like leather.

2: APPLY PAINT
Pour on paint straight from the bottle. Brush the paint over the paper, adding colors as you need them. When dry, turn the paper over and coat the other side with paint, using the same color or a new one. Let dry.
 I used a dark green for what will be the outside of the pouch, and a warm orange for the inside.

3: TEAR OUT POUCH FORM
Tear up the painted paper, trying for uneven edges and a big enough piece to use as a basic pouch form.

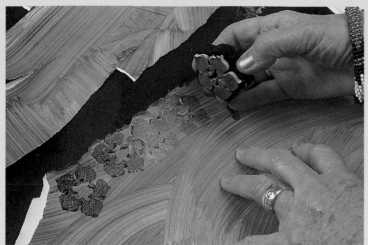

4: ADD DECORATIVE STAMPING

Try stamping patterns onto your paper, using acrylics mixed with gel to make a thick paint. Stamped patterns can help cover any unsightly edges.

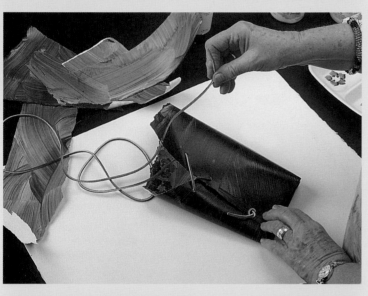

5: FOLD PAPER INTO A POUCH

Use a hole punch or nail to make unevenly spaced holes in the paper where you want the paper to fold together and stay in pouch form. Thread a leather thong through the holes to keep the pouch form secure.

If any edges do not stay firmly together, use some gel as glue where needed.

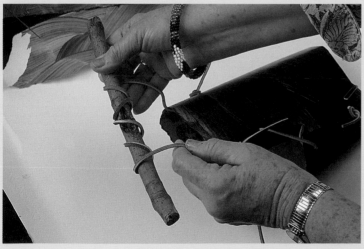

6: GIVE THE POUCH A HANGER

Find a stick to use as a natural-looking hanger for your pouch. Loop the leather thong around the stick, securing the thong's ends to the pouch through a hole.

"Don't do anything predictable!" —Mary Todd Beam

7: FILL YOUR POUCH

Stuff the pouch with raffia or any dried natural material. Allow touches of the inner pouch colors to show.

8: ADD FEATHERS

Coat the hanging stick with thick gel medium as a glue and then apply feathers to the stick. Let dry.

"When the miracle of life in nature inspires me to give it form and color, I can only hope that the viewer shares its celebration and experiences the inner peace this joyful journey gives the soul."

—Yvonne J. Lappas

9: ADD SHELLS

Use gel to apply shells to thread. Let dry. When the shells have dried securely, apply thread to the bottom of the pouch with gel and let dry in place.

10: ADD FINAL TOUCHES

Decorate your pouch with any small special found objects, applying these with gel, and hang the pouch from the stick.

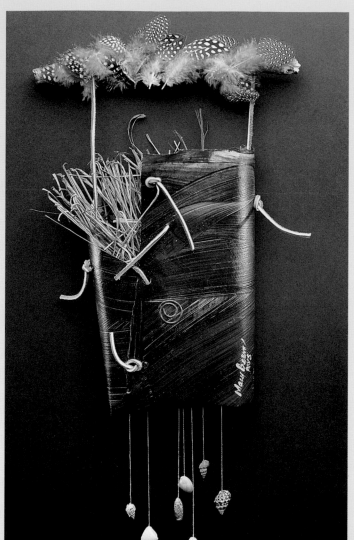

DEMETER'S BASKET * *Yvonne J. Lappas* * 25"×15" (64cm×38cm)

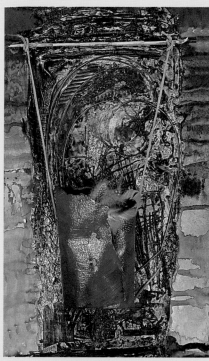

Lappas used her pouch as collage.

* *Watercolor paper, acrylics, gesso, feathers, leather and sticks* * *Collection of the artist*

Jones used her pouch as an appendage to a larger work of art.

WISH BASKET * *Vera A. Jones* * 9"×4" (23cm×10cm)

* *Watercolor paper, acrylic, feathers, bone and dried plant materials* * *Collection of the artist*

painting ON PLASTIC

hy limit yourself to painting on paper when acrylic paints are so versatile? Acrylics are polymer based, so painting them on plastic is not a problem. With acrylics and plastic you can create freestanding works of art or window hangings.

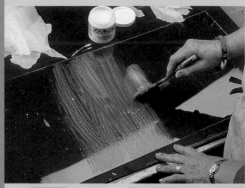

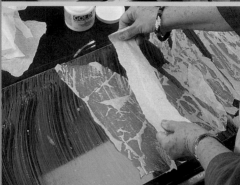

1: PREPARE THE SURFACE

Place your Plexiglas on a dark surface so you will be able to see your work on this clear surface. Use your 3-inch (76mm) bristle brush to put gel medium or tar gel down as an adhesive agent on the Plexiglas.

Overlap torn pieces of tissue or rice paper onto the Plexiglas, arranging them so they form an interesting composition of shapes. You don't have to press all the paper into the gel: Leave some edges loose or rumpled for variety.

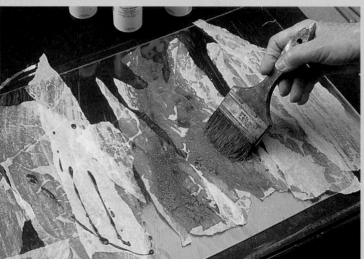

2: APPLY PAINT

Apply paint using a light touch and enough water so the paint moves around easily.

Use a spray bottle to keep the paint wet and flowing if needed. Working fast and wet with your paint can produce beautiful floral effects.

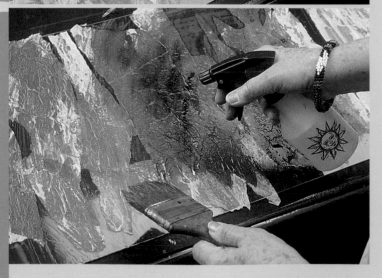

MATERIALS LIST

Surface
Plexiglas

Brush
3-inch (76mm) flat bristle

Paints
Fluid acrylics: Turquoise (Phthalo),
 Quinacridone Crimson,
 Quinacridone Gold

Other
Gel medium or clear tar gel
Spoon
Tissue or rice paper torn up into
 irregular shapes
Spray bottle

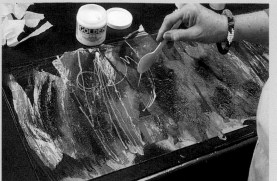

3: BUILD UP YOUR SURFACE

Drip gel medium or tar gel in a small stream from a spoon to create designs over the paint. Make shapes, birds, symbols, etc.—the tar gel holds its shape when dry. Add another layer of paper and paint.

4: ADD FINAL TOUCHES

Hold your painting up to a light and see if your shapes and values form a pleasing design. You can always add more layers of paper or paint if needed.

Nelson is an author of note, the founder of the Society of Layerists in Multi-Media and a visionary artist. Her media allows the viewer to look through or to "see beyond" to spiritual reference.

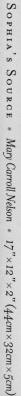

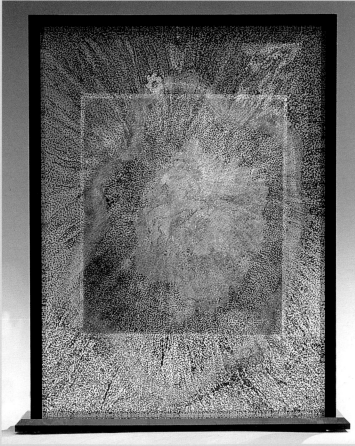

SOPHIA'S SOURCE ∗ *Mary Carroll Nelson* ∗ 17" × 12" × 2" (44cm × 32cm × 5cm)

∗ *Plexiglas, ink and film* ∗ *Collection of the artist*

Where Else Will Your Creativity Lead?

Often revealing spiritual content, Newman's work becomes an altar where we are awed by the beauty of his thoughts.

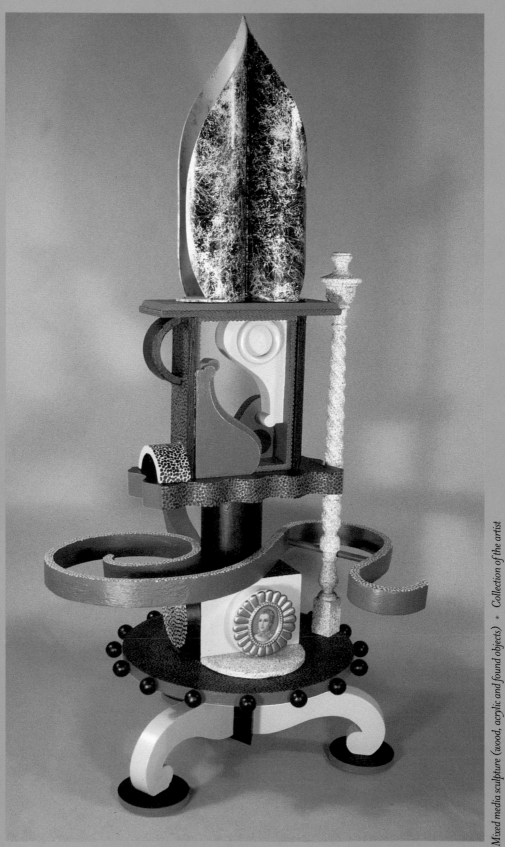

BISHOP * Richard Newman * 45"×23"×20" (114cm×58cm×51cm) *

*Mixed media sculpture (wood, acrylic and found objects) * Collection of the artist*

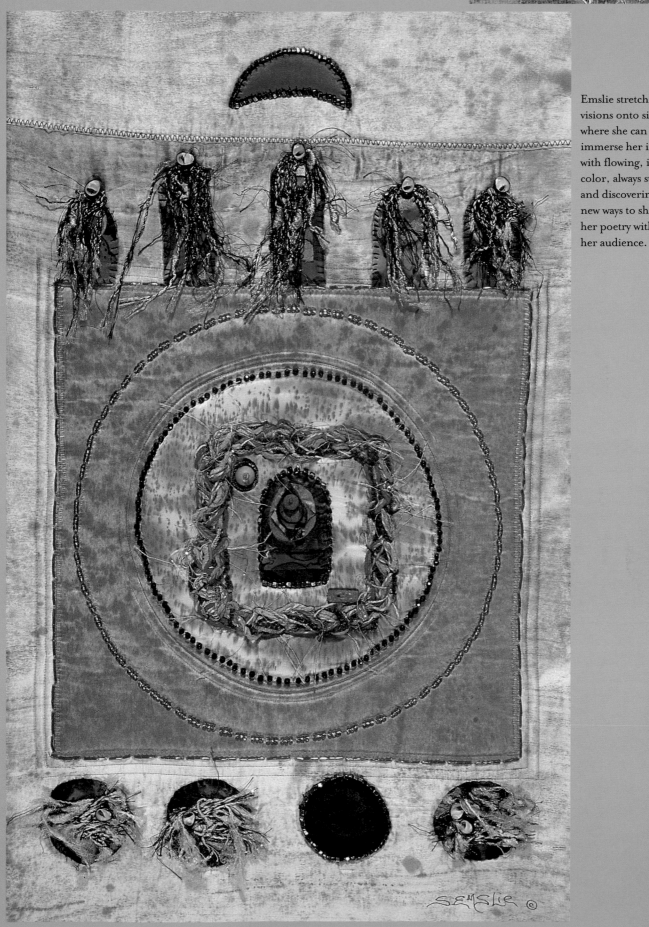

Emslie stretches her
visions onto silk,
where she can
immerse her images
with flowing, intense
color, always striving
and discovering
new ways to share
her poetry with
her audience.

SIBLINGS * Sally Emslie * 40"×20" (102cm×51cm)

* Hand-dyed silk, glass beads, floss and found objects * Collection of Sue Quinn

Conclusion: Finding the Visual Poet

Poet—

1. One endowed with great imaginative, emotional, or intuitive power and capable of expressing his conceptions, passion, or intuitions in appropriate language.

2. One (as a creative artist) of great imaginative and expressive capabilities and special sensitivities to the medium.

—Merriam Webster's Collegiate Dictionary

WHERE DO YOU FIT IN?

Now that you have built a repertoire of techniques, it's time to do the homework and search for your unique inspiration. We have this inspiration all along, but often it is so close to us that we don't see it.

I hope you can use the demonstrations in this book to construct your path and determine your personal course. Select those materials and techniques that free you in expressing your direction. Select those that suit your personality, those that bypass the struggle and allow inspiration to flow from the tips of your fingers. Combine demonstrations to construct new ideas. Eliminate those that are a distraction. Keep your palette simple. Keep your materials simple. Rely only on your ideas, inspiration and ability. The rest will follow.

FASHION YOUR POETRY WITH PAINT

During my thirty-five years as a painter, I've found that being a painter is a high calling. Paintings can express emotion and thoughts in a way that nothing else can. Bringing your thoughts into being is the magic of creation. We can change the way that paint looks on the paper, but the act of painting also changes us.

SEARCHING FOR THE POET

As I've looked around, I've found that certain works of art are very compelling and moving to me. I've asked myself why this is. Here are a few select qualities that I believe these works embody.

1. Metaphor

The visual poet sees the significance in the subjects he paints and knows how to make this meaning apparent to the thoughtful viewer. Objects take on a special consideration and they are dealt with in a meaningful light. He has spent the time to put much thought into his work.

2. Narrow Focus

Once the visual poet has found his path, his energies are directed toward a narrow focus. Each work tends to grow from the preceding one. Although his focus is narrow, it grows.

3. Humble Subject Matter

Although painters have the world to choose from, the humble subjects are, to me, the most moving. The visual poet knows of the charm that is contained in the objects that are close to us humans.

4. Everyday Experiences

All humans have much in common. We may call it a universal human experience. There are some paintings that cross barriers and are understood and felt by all of us regardless of our race, sex or language.

"Artists, like poets, create works that are distillations of rich life experiences as well as investigations of new realities." —Louise Cadillac

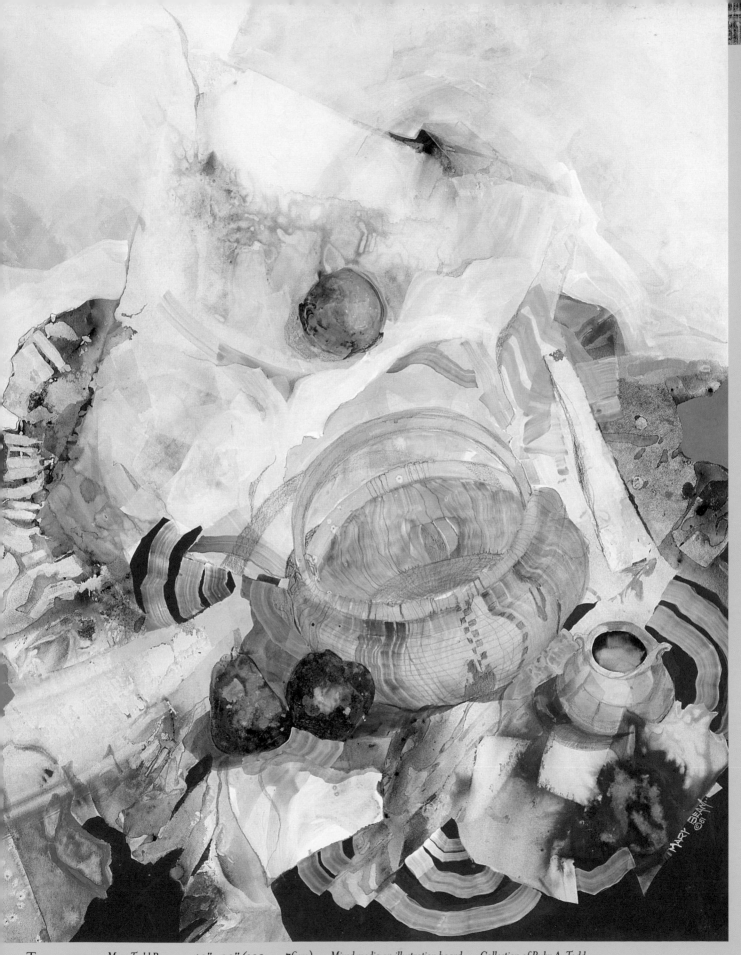

TIMELESS * *Mary Todd Beam* * *40"×30" (102cm×76cm)* * *Mixed media on illustration board* * *Collection of Ruby A. Todd*

Gallery

CORRAL I * *Louise Cadillac* * *13"×16" (33cm×41cm)* * *Oil-based ink on paper* *

Ambiance and atmosphere often provide the thematic material for Cadillac's work. She begins work with a vague theme, or might be guided by a burning idea. This painting is part of a series in which Cadillac tries to evoke the desolate beauty of the western desert.

Ferbert is an expert visual poet. She glorifies humble subjects by bathing them in sunlight. How can a common weed be elevated to these heights? The old bricks in the background seem to become a cathedral mimicking the glory f milkweeds. Her work is always filled with metaphor and arcane meaning.

MILKWEED AND ARCH * *Mary Lou Ferbert* * *58"×39" (150cm×101cm)*

Transparent watercolor on paper * *Collection of Mr. and Mrs. Thomas L. Dempsey* *

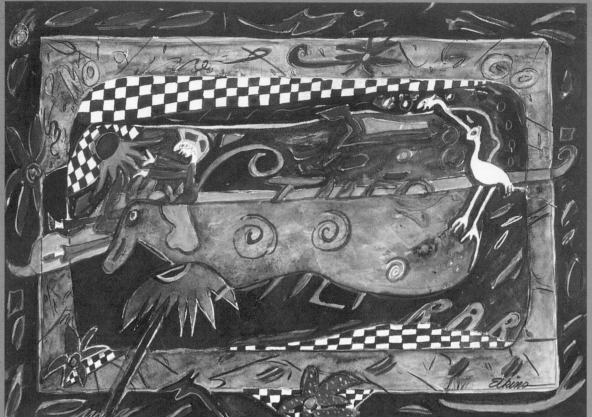

Elkins fills her canvas and her visual world with playful and entertaining objects. Dynamic rhythms evoke a sense of childlike joys shared by most people.

Watercolor on paper ✳ *Collection of Mary Helen Bradford*

LUV THERAPY: DOGGONE IT DIDN'T WORK ✳ *Toni M. Elkins* ✳ *11"×15" (28cm×38cm)* ✳

Masterfield uses broad strokes and intense color saturations to portray the mood and motion of the sea. Each painting is almost a microcosm of some aspect of the ocean. Abandoning a literal approach she makes the image more real by saturating the scene with her creativity.

MELODY (DETAIL)

✳ *Maxine Masterfield* ✳ *42"×42" (107cm×107cm)* ✳ *Waterbase liquid enamel on canvas* ✳ *Collection of the artist*

ELEGANT SWINE II · *Robert Fields* ·

36" × 36" (91cm × 91cm) · Watercolor on gouache · Collection of the artist

Fields shows us more about the subject by placing it in an environment with elegant roses. How can pigs become elegant? He jogs our imagination in a search for meaning. Sometimes we need to see a subject's opposite to appreciate the subject's positive qualities. Fields challenges us to play his game of finding commonalities between these two complete opposites. Can we as creative artists look for subjects that are totally different and reveal their shared qualities?

Ross uses painterly washes in a random man-
ner and reads the images as she progresses
into the work. The images are drawn through
the spontaneous action of the paint.

SPIRIT RENEWAL * *Eileen Ross* * *22" × 30" (56cm × 76cm)*

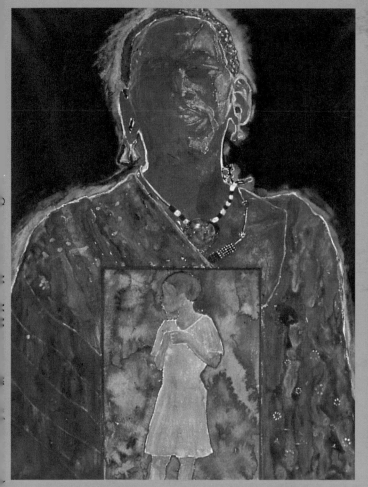

*Watercolor, collage and acrylic on paper * Collection of Mr. Rechenbach*

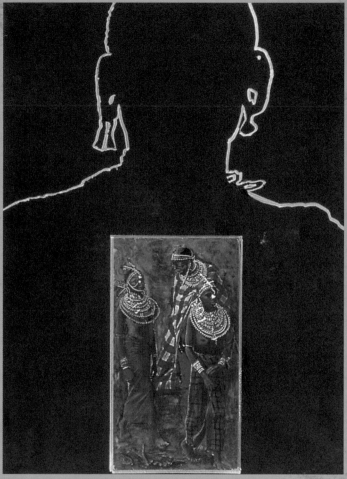

This painting appeals to the imagination through the use of figures and the stories that can be told through their intriguing expressions.

Contributors

Trish Arnold
page 98, *Dance—Ecnad*, © Trish Arnold

Carole D. Barnes
page III, *Ancient Altar*; page 40, *Ancient Language*; © Carole D. Barnes

Julie Beam
page 5, *Floral II*, © Julie Beam

Edward Betts
page 83, *Night Shore*, © Edward Betts

Gerald F. Brommer
page 59, *Santorini Impression*, © Gerald F. Brommer

Carrie Burns Brown
page 115, *Syncopation*, © Carrie Burns Brown

Peggy Brown
page 29, *In Motion*, © Peggy Brown

Chica Brunsvold
page 99, *Jurassic*, © Chica Brunsvold

Robert Burridge
page 57, *Farmers' Market*, © Robert Burridge

Louise Cadillac
page 134, *Corral I*, © Louise Cadillac

Cheryl Curnick
page 114, *Patterns & Paint*, © Cheryl Curnick

Jean Deemer
page 87, *Faultline*, © Jean Deemer

Dr. Charles Dietz
page 8, *Red Spot*; page 8, Foreword; © Dr. Charles Dietz

Donald L. Dodrill
page 87, *Time Mechanisms*; page 55, *Cape Hatteras Light*; © Donald L. Dodrill

Ganga Duleep
page 50, *Aftermath*, © Ganga Duleep

Toni M. Elkins
page 136, *Luv Therapy: Doggone It Didn't Work*, © Toni M. Elkins

Sally Emslie
page 131, *Siblings*, © Sally Emslie

Mary Lou Ferbert
page 135, *Milkweed and Arch*, © Mary Lou Ferbert

Robert Fields
page 137, *Elegant Swine II*, © Robert Fields

Richard French
page 15, *Great White Bird*, © Richard French

Fanchon c Gerstenberg
page 56, *Off to See the Wizard*, © Fanchon c Gerstenberg

Jean Grastorf
page 93, *Key West House*, © Jean Grastorf

Taylor Ikin
page 56, *Up River*, © Taylor Ikin

Vera A. Jones
page 53, *White Black Sixteen*; page 127, *Wish Basket*; © Vera A. Jones

Yvonne J. Lappas
page 127, *Demeter's Basket*, © Yvonne J. Lappas

Marie Dolmas Lekorenos
page 98, *Between Places and Times #1*, © Marie Dolmas Lekorenos

Guy Lipscomb
page 115, *Three Gems II*, © Guy Lipscomb

Katherine Chang Liu
page 54, *Chain*, © Katherine Chang Liu

Resources

Societies

Contact your local arts community for more information on these or similar societies, or contact the societies directly if you have further questions.

AMERICAN WATERCOLOR SOCIETY
PMB 481C
1220 Airline, Suite 130A
Corpus Christi, TX 78412
www.watercolor-online.com/aws/

FRONTIER COLLAGE SOCIETY
6203 Burk Burnett Court
Austin, TX 78749-1876

INTERNATIONAL SOCIETY OF EXPERIMENTAL ARTISTS
1920 Adams Lane
Sarasota, FL 34236

NATIONAL COLLAGE SOCIETY, INC.
254 West Streetsboro Street
Hudson, OH 44236
nationalcollage@juno.com
http://pages.hotbot.com/arts/national-collage/

NATIONAL SOCIETY OF PAINTERS IN CASEIN AND ACRYLIC
To join, send SASE:
Robert Sanstrom
377 W. Chester Avenue
Port Chester, NY 10573

To enter send SASE:
Douglas Wiltraut
969 Catasauqua Road
Whitehall, PA 18052

NATIONAL WATERCOLOR SOCIETY
Membership Director
915 S. Pacific Avenue
San Pedro, CA 90731
www.nws-online.org/

SOCIETY OF LAYERISTS IN MULTI-MEDIA
Mary Carroll Nelson
1408 Georgia NE
Albuquerque, NM 87110

Supplies

Check your local art supply retailer for these or similar supplies, or call the manufacturer directly to find a supplier near you.

CRESCENT CARDBOARD COMPANY, L.L.C.
(800) 323-1055
www.crescent-cardboard.com
Illustration board

DA VINCI PAINT CO.
(800) 55-DVP-55
www.davincipaints.com
Watercolor paints

GOLDEN ARTIST COLORS, INC.
(800) 959-6543
barbara@goldenpaints.com
www.goldenpaints.com
Fluid acrylics, gel mediums, gesso, Acrylic Flow Release, iridescent and interference paints

INVERESK PLC
www.inveresk.co.uk
Saunders Waterford and Bockingford watercolor paper

YUPO CORPORATION
(888) USE-YUPO
www.yupo.com
Yupo synthetic paper

Index